IMAGES
of America

CONSOLIDATED
AIRCRAFT CORPORATION

ON THE COVER: The Consolidated Aircraft Corporation contributed to changing San Diego from a small coastal resort and navy town to a modern community and industrial center. Along the way, the company built many famous airplanes, like the PBY Catalina and B-24 Liberator. Such was the demand for the B-24 army bomber that it was produced at five different factories, including the huge government-built facility at Fort Worth, Texas. Visible in this view are Liberators for the Royal Air Force (RAF) and B-24s for the U.S. Army Air Force (USAAF), as well as camouflaged C-87 cargo versions in the background. The aircraft in the foreground, 42-50395, would go on to become "Goona's Garbage Wagon" with the 455th Bomb Group, 15th Air Force, in Italy. (San Diego Air and Space Museum.)

IMAGES
of America

CONSOLIDATED
AIRCRAFT CORPORATION

Katrina Pescador and Mark Aldrich
San Diego Air and Space Museum

Copyright © 2008 by Katrina Pescador and Mark Aldrich, San Diego Air and Space Museum
ISBN 978-0-7385-5938-4

Published by Arcadia Publishing
Charleston SC, Chicago IL, Portsmouth NH, San Francisco CA

Printed in the United States of America

Library of Congress Catalog Card Number: 2008922696

For all general information contact Arcadia Publishing at:
Telephone 843-853-2070
Fax 843-853-0044
E-mail sales@arcadiapublishing.com
For customer service and orders:
Toll-Free 1-888-313-2665

Visit us on the Internet at www.arcadiapublishing.com

Dedicated to all the men and women who made Consolidated/Convair
one of the nation's leading aircraft manufacturers.

Contents

Acknowledgments		6
Introduction		7
1.	Reuben H. Fleet	9
2.	Sunny San Diego	35
3.	Consolidated Goes to War	57
4.	An Industry Leader	85
5.	To the Moon and Beyond	115

ACKNOWLEDGMENTS

The San Diego Air and Space Museum's Library and Archives is the third largest aerospace library in the nation and holds many unique, rare, and one-of-a-kind items. The collection also holds the depth and breadth of San Diego's rich aviation heritage, consisting of books, periodicals, films, videotapes, more than two million photographs, aircraft manuals, and drawings, along with other archival materials.

 We are greatly appreciative to all the museum staff and volunteers who have helped the museum over the years to carry out its mission to preserve and make available the research published, documentary, and visual materials that chronicle the development of aerospace technology and experience. All the images used in this publication were selected from the museum's extensive photograph collection. In order to assist with the continued care of the collection, all author proceeds from the book will be donated to the library and archives. Special thanks to volunteers John Lull, Dennis Stewart, Dan Heald, Dave Barnett, Miles Todd, Bob Bradley, and Nick Galatis, and to Alan Renga, assistant archivist, for his assistance in editing text and scanning images.

 We also wish to thank our editor at Arcadia Publishing, Debbie Seracini, for her guidance and support. Her enthusiasm has encouraged us to publish several titles for Arcadia and inform the public on San Diego's significant aviation heritage.

INTRODUCTION

Founded by Maj. Reuben H. Fleet in 1923, Consolidated Aircraft Corporation (later Convair) became one of the most significant aircraft manufacturers in American history.

By 1933, beset by weather and labor problems in the Northeast, Fleet and his board of directors were contemplating a move to the West Coast. Offers were made by various cities in Los Angeles County and by San Diego. Attracted by the mild climate of San Diego; proximity to a year-round flying boat harbor, a major naval air station, a first-class airport; and favorable financial terms; Fleet decided to move Consolidated Aircraft Corporation from New York to California in 1933. In less than two years, Fleet had moved all of the equipment, tools, and materials to San Diego by rail, and the new plant was ready for its dedication on Sunday, October 20, 1935. Moving with him were approximately 200 corporate officers, key personnel, and their families. For roughly the next 60 years, this prolific company and its products were synonymous with San Diego.

Except for the U.S. Navy, Major Fleet's company was the largest single employer in the county, employing in excess of 45,000 people in San Diego at one time. The impact on the community was profound and long-lasting. Whole communities sprang up just to house the influx of workers and their families. The city's infrastructure benefited from huge increases in the tax base with dozens of new schools, street improvements, and other civic benefits. In the meantime, the contribution to the war effort was immense. In the month of January 1944 alone, the San Diego plant turned out 328 B-24s, PBYs, and PB2Ys, an average of over 10 planes a day.

Consolidated was responsible for building some of the most important aircraft in aviation history, including the PBY Catalina, B-24 Liberator, F-102 Delta Dagger, and F-106 Delta Dart, as well as the reliable Atlas launch vehicle, which was vital in sending America into space. Some of the most influential designs also came from the imaginations of the company's designers. Aircraft like the XF-92, XFY-1 Pogo, and R3Y Tradewind have all had a long-term impact on aircraft and engine development. Before production of aircraft finally ceased in 1964, Consolidated/Convair would deliver 12,747 complete aircraft.

With the cold war and the space race, Convair focused on the Atlas and other launch vehicles. The Atlas launched the first man into space and led to the first man on the moon. After 37 years of producing, integrating, and testing launch vehicles, the General Dynamics Space System Division was sold to Lockheed Martin Astronautics in Denver.

The photographs in this publication showcase many of the people and projects that made Consolidated/Convair such an important aerospace company.

One

Reuben H. Fleet

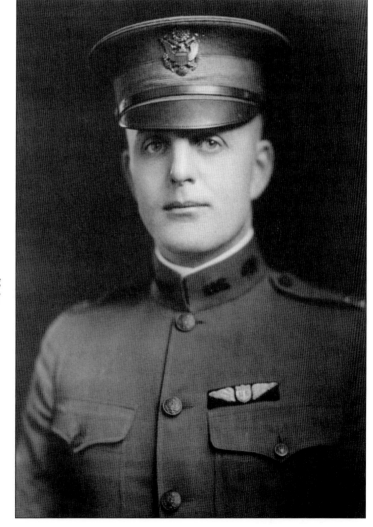

Reuben Hollis Fleet was born on March 6, 1887, in Montesano, Washington. Graduating from the Culver Military Academy in 1906, he went on to form a real estate business and became the youngest member of the state legislature in 1915. Just days before the United States entered the First World War, Fleet volunteered for pilot training with the U.S. Army's Signal Corps Aviation Section, thus beginning his long career in aviation.

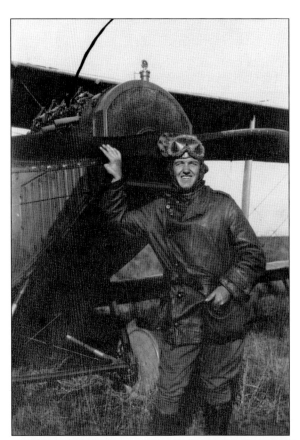

Fleet joined the U.S. Army Signal Corps on March 29, 1917, attending flight training at the army's aviation school at Rockwell Field, San Diego, California. Seen here is Fleet posing in front of one of Rockwell's Curtiss Jenny trainers.

Here is the sixth 1917 Junior Military Aviator (JMA) class of San Diego, California. From left to right are Captain Wright, Lieutenant Furlow, Lieutenant Shields, Lieutenant Colonel Turner (USMC), Lieutenant Smith, Captain Fleet, Captain Stroup, and Lieutenant Scheleen. Upon receiving his pilot wings as military aviator No. 74, Fleet was assigned to the Army Air Service, headquartered in Washington, D.C., to plan and supervise aircrew training. Under his direction, the program trained over 11,000 army pilots in less than two years.

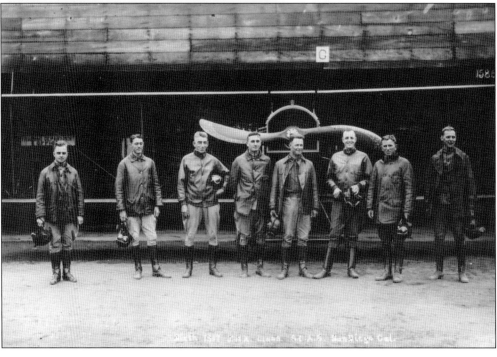

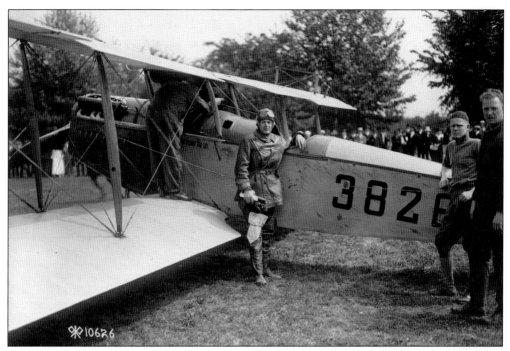

On May 15, 1918, the Post Office Department began scheduled airmail service between New York and Washington, D.C., utilizing army planes and pilots. Seen here on that day is Reuben Fleet. He was appointed officer-in-charge of the Aerial Mail Service by Henry "Hap" Arnold, the assistant Air Corps chief and future commander of the U.S. Army Air Forces.

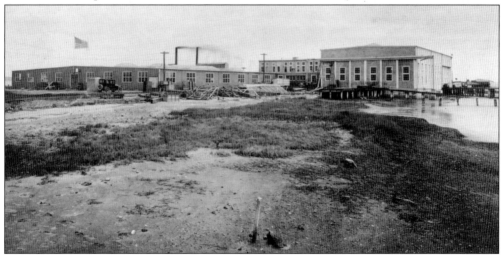

In 1919, Fleet was reassigned to McCook Field in Dayton, Ohio, at the U.S. Army Flight Test Center, where he made contacts with U.S. aircraft contractors and manufacturers. Fleet left the Signal Corps as a major in 1922 to begin his distinguished career as an aviation industrialist. He turned down executive positions with Boeing and Curtiss before joining the Gallaudet Aircraft Corporation as vice president and general manager until the company folded. Acquiring the assets and engineering talents of Gallaudet Aircraft Corporation and the Dayton-Wright Airplane Company, Fleet combined the two into a new firm, Consolidated Aircraft Corporation, on May 29, 1923.

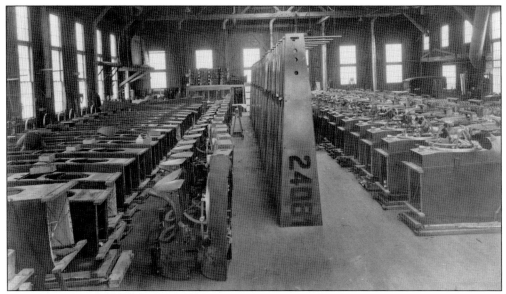

Located in the Gallaudet aircraft factory in East Greenwich, Rhode Island, the newly formed company picked up the Gallaudet contracts for 20 TW-3 trainers as well as the services of Col. Virginius Clark, designer of the trainer. Fleet originally met Clark at McCook Field. Clark had been the chief aeronautical engineer for the U.S. Army, leaving in 1920 to join the General Motors' Dayton-Wright Company. Here is the interior of the Gallaudet plant on June 1, 1923.

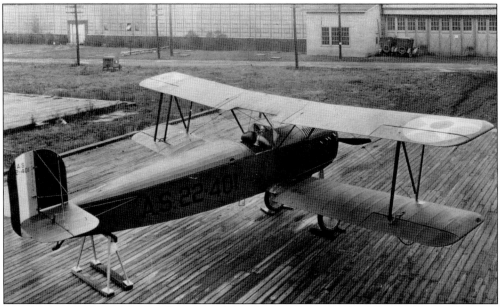

The first airplane produced with a Consolidated nameplate was the Thomas-Morse–designed TW-3 trainer for the U.S. Army Air Corps. By the time the contract for the type was finally signed by the War Department, Consolidated had acquired the manufacturing rights and proceeded to build 20 of the type, which were all delivered to Brooks Field, San Antonio, Texas, by the end of 1924. Powered by a 180-horsepower Wright-Hispano E engine, the TW-3 featured side-by-side seating for the student and instructor. This factory photograph shows a production aircraft, serial 22-401.

In service as a trainer at Brooks Field, this plane had some of its cowling panels removed to improve engine cooling and pilot visibility. Experience with the TW-3 convinced the army to look at tandem seating for its future trainers.

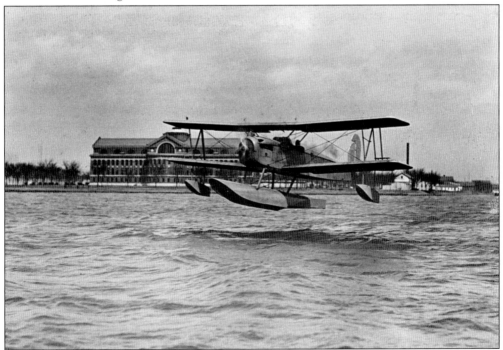

One TW-3 was transferred to the navy and tested with a single float as Bureau No. A-6730. The only TW-3 to be fitted with floats, it is seen here on a test flight at Naval Air Station (NAS) Anacostia.

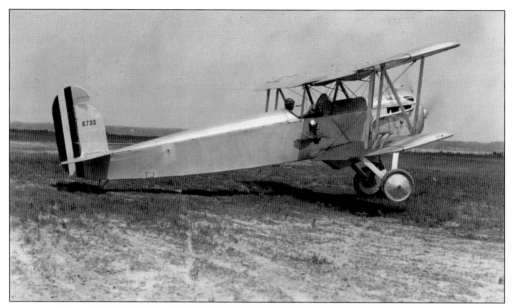

After completion of flight tests at Anacostia, the TW-3 was transferred yet again, this time to the Marine Corps for use as a mosquito abatement aircraft with the original wheeled landing gear reinstalled. Seen here at Quantico, Virginia, the plane bears an image of a mosquito vanquished by a knight on the fuselage. The pesticide applicator can be seen beneath the fuselage.

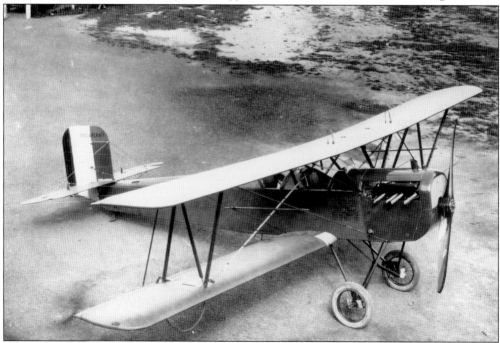

It was always in Rueben Fleet's nature to simplify designs and processes. This is evident in the first pure Consolidated design, the PT-1. The PT-1 used a steel tube fuselage construction and two tandem seats to produce an extremely robust design intended to replace the TW-3. Nicknamed the "Trusty" for its gentle spin characteristics, the PT was the first postwar trainer to be bought by the War Department in large numbers.

With business growing, Fleet moved his company from the Gallaudet aircraft factory at East Greenwich, Rhode Island, to Buffalo, New York, in 1924. Consolidated signed a 10-year lease at the Curtiss plant for 28,351 square feet, with an option to expand if business warranted. By 1931, Consolidated covered 236,000 square feet. The construction of PT-1s can be seen here at the Buffalo plant around 1925, with women in the foreground sewing fabric for the aircraft.

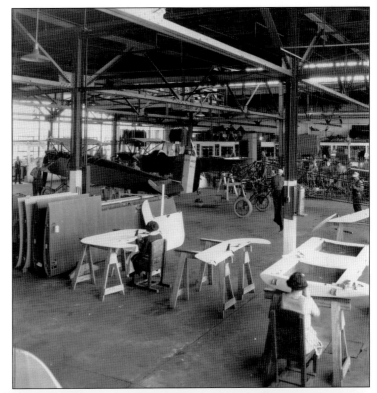

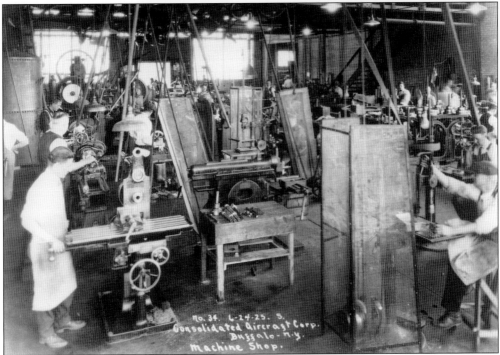

Seen here is the machine shop at the Buffalo plant in 1925. Lathes, drill presses, and other equipment were powered by belts connected overhead. In those days, workers wore dress shirts and ties.

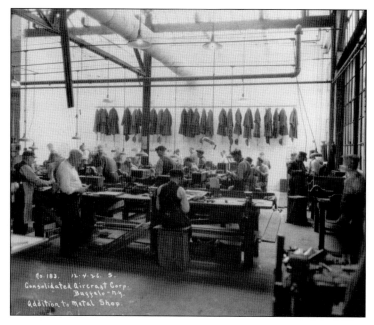

The factory expansion meant more room, better light, and improved safety conditions for many of the various departments. This image shows some of the improvements made to the machine and metal shop. Because the weather in Buffalo was an issue both inside and outside, the plant employees often came to work in heavy coats. During the work day, these were suspended from cables and rods, visible here against the windows.

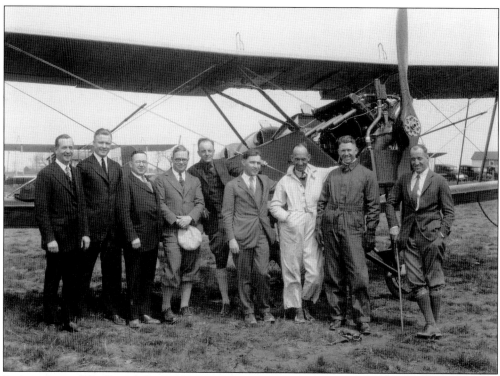

Seen in front of the first production PT-1 are, from left to right, George Newman, factory manager; Ray Whitman, chief inspector; Thomas Kenny, treasurer; Col. V. E. Clark, chief engineer; Maj. Reuben Fleet, founder; James L. Kelly, Air Service representative; Lt. K. B. Wolfe, later commanding general of Air Material Command; Lt. Carl A. Cover, later chief test pilot/vice president of Douglas Aircraft Company; and Maj. Ralph Royce, commanding officer of Brooks Field.

A PT-1 Trusty flown by Army Air Corps reserve captain Frank Siefert with San Diego mayor Harry C. Clark as passenger was the first airplane to land at San Diego's new Lindbergh Field. The PT-1 is in the background with a delegation of civic leaders. This aircraft is on display at the San Diego Air and Space Museum. Only two PT-1s remain in existence.

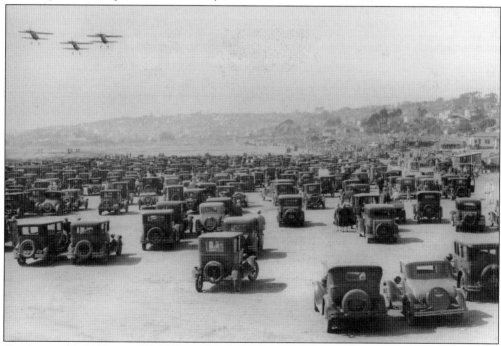

On August 16, 1928, over 50,000 people watched the dedication of San Diego's new municipal airport, Lindbergh Field. Flyovers and parachute jumps were included as part of the ceremonies. This great airport would later contribute to Fleet's decision to relocate his company to San Diego.

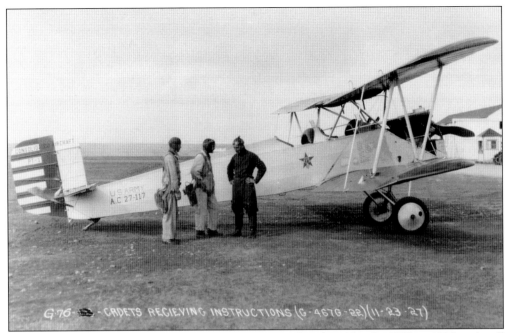

The PT-1 was in service with the Army Air Corps until replaced by the PT-3 in 1928 and well into the early 1930s with the National Guard. This photograph, taken at Rockwell Field in San Diego, shows two cadets receiving directions from their instructor in front of a PT-1 on November 23, 1927. During the first year of operations, PT-1s were used to train over 500 students without serious injury.

Production for the PT-1 totaled 220 aircraft, and this success led to Consolidated's first foreign order. Siam (now Thailand) took delivery of these four machines in 1928, seen here after assembly at a military airfield near Bangkok.

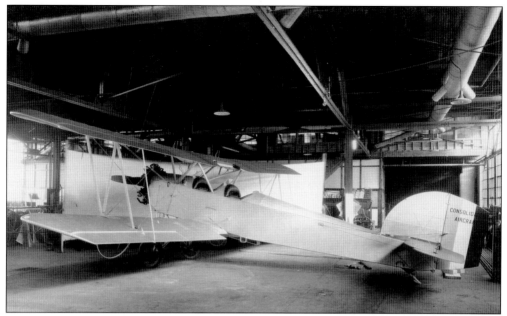

In 1925, the navy tested the PT-1 against 14 other proposals for a contract to provide a new trainer. The Consolidated design emerged as the clear winner. The navy required the plane to be powered by the reliable air-cooled Wright Whirlwind radial engine. The design also had to be modified to allow operation from both float and wheeled landing gear. The navy designated the plane the NY series. This photograph was taken at the Buffalo factory in June 1925.

Operated on floats principally at NAS Pensacola, the NY series was just as popular with navy pilots as it had been with the Army Air Corps. The radial versions became known as the Husky. At least one remained in service as late as 1937, a remarkable achievement for a training plane whose life expectancy was more likely to be three to four years.

Over 340 NY trainers would eventually be delivered to the navy. Some, like the example shown here, served with reserve units. Others were modified for use as gunnery trainers, known as the NY-1A, with a machine gun mounted in the aft cockpit.

The NY-2 began deliveries in 1926. Powered by a more powerful Wright J-5, over 200 were delivered in several different versions. This particular airplane is a standard production model assigned to VN-15R, the NAS Seattle–based reserve squadron.

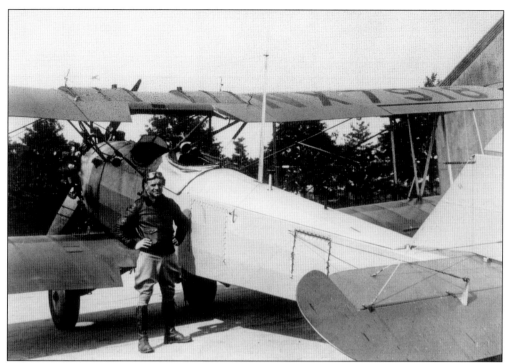

Lt. Jimmy Doolittle is pictured in the NY-2 he chose to demonstrate "blind-flying" techniques at Mitchell Field, Long Island. The plane's inherent stability made it an excellent choice for Doolittle, and on September 24, 1929, with Lt. Ben Kelsey along as a safety pilot in the front cockpit, he flew the plane, registered NX7918, under a hood from the backseat for the first time.

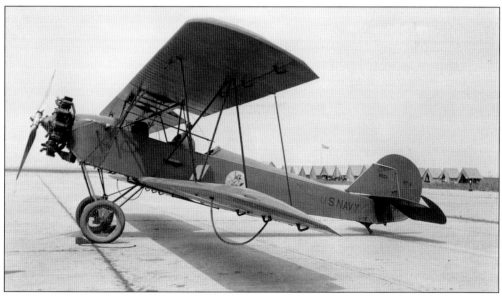

Built primarily for use by navy and marine reserve squadrons, the last production version of the Husky was the NY-3. While the unit to which this machine belonged is unclear, it carries a colorful insignia with Mickey Mouse riding a goose. Twenty aircraft of this version were built.

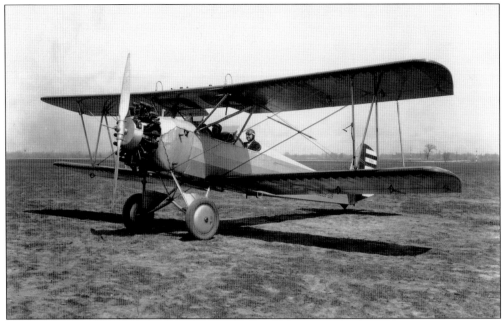

Developed from the PT-3, the O-17 was intended as a new advanced trainer for the army. Given the secondary mission of observation, the aircraft was designated as an "O" type. Equipped with wheel brakes, streamlining, and improved landing gear for rough field service, 29 were delivered to the army, mostly for the use of National Guard units, and three more to the Royal Canadian Air Force.

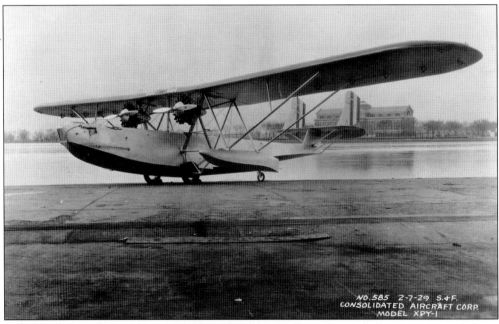

In 1927, Fleet decided to enter a U.S. Navy design competition for a new long-range patrol plane. The specifications called for an all-metal monoplane with two large radial engines and a 100-foot wingspan. Consolidated's offering was designed by Isaac Machlin "Mac" Laddon. The design, named the Admiral and designated the XPY-1, won the competition in February 1928.

Hired by Fleet in 1927, Isaac M. Laddon was Consolidated's chief engineer. He was later promoted to executive vice president, general manager, and director of Consolidated. Fleet and Laddon originally met years earlier at McCook Field while in the Army Signal Corps.

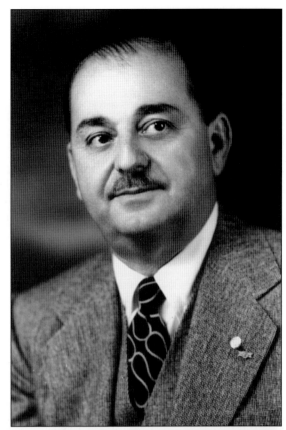

Construction of the XPY-1 started in January 1928 and was not finished until December. Since Lake Erie and the Niagara River were both frozen solid, it was shipped by rail to NAS Anacostia for final assembly and test flying. This restriction would later contribute to the decision to relocate the company to San Diego. Seen here under construction in the Buffalo factory, the all-metal assembly of the hull and floats is evident. The XPY-1 was the largest flying boat built in the United States at the time.

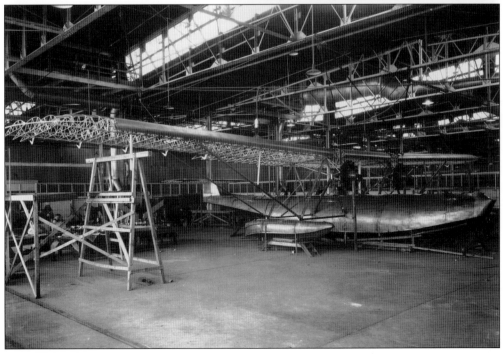

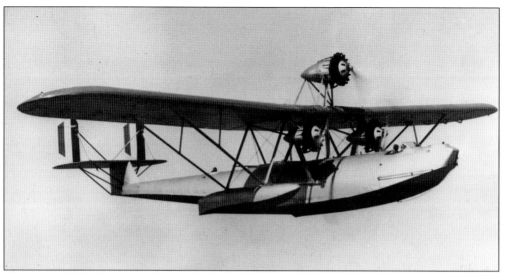

The navy specified a maximum speed of 135 miles per hour. Since the prototype was only capable of 118 miles per hour, a decision was made to experiment with a third engine mounted over the wing. While this increased speed, it made it impossible to fit the plane into the hangars of the period. It was also dangerous to service at sea, so the requirement was lifted and the engine removed.

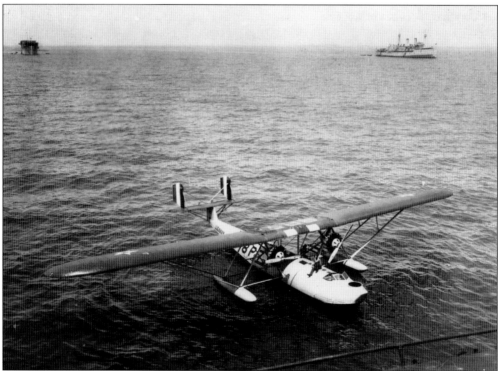

Congress required the navy to put its initial contract for nine aircraft up for competitive bid. Unfortunately, Consolidated had to recoup its developmental costs by adding them to their bid and lost the contract to Martin Aircraft. The Martin P3M-1 in this photograph is serving with Patrol Squadron Eight, and its resemblance to the original Consolidated design is obvious.

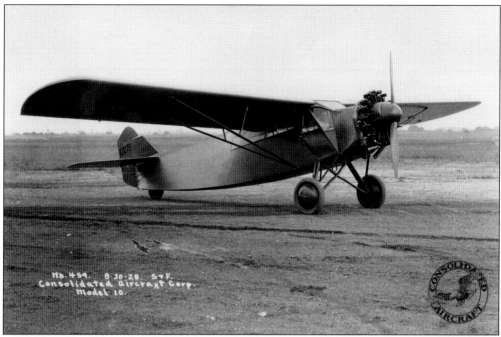

The Model 10 was designed by Joseph M. Gwinn Jr. to take advantage of the expected commercial aviation opportunities of the late 1920s. The airplane featured several very unusual features potential customers might not have been comfortable with, including a triangular fuselage cross section and overhead control column. This contributed to the type's lack of success.

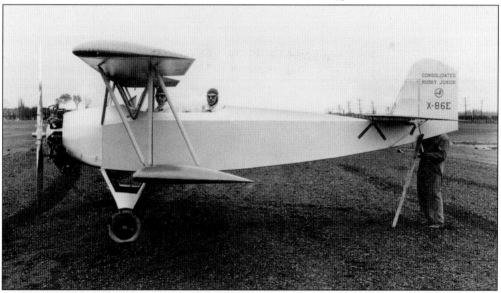

In 1928, Fleet and a small group of engineers and test pilots designed what they hoped would be a new trainer that could repeat the success enjoyed by the Husky and Trusty series. Built in less than a month, the first Model 14 Husky Junior was easy to build, light on the controls, and fairly inexpensive. Seen here with Fleet at the controls is the prototype on November 9, 1928. The company's board of directors was not convinced there was a market for a civilian sport trainer. Fleet purchased the rights himself and gave the first contract to Consolidated for 110 aircraft.

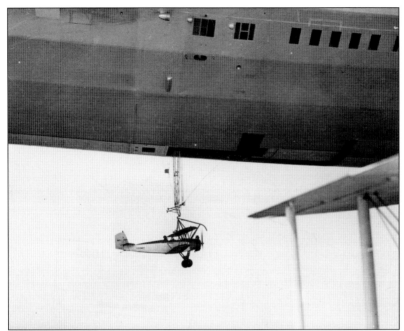

Both the army and navy were among the many customers for the Model 14, albeit in small quantities. One of the navy's six aircraft, designated N2Y-1, were used as trainers for pilots assigned to fly Curtiss F9C Skyhook fighters from airships. One is seen here hooking on to the USS *Akron* in May 1932.

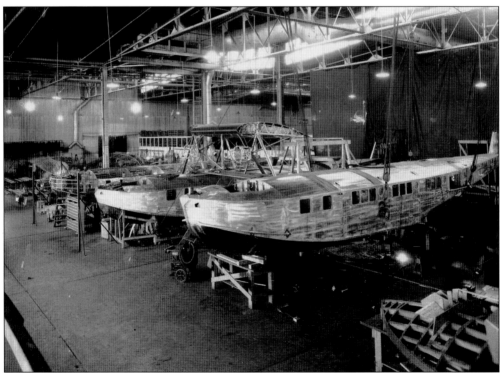

While disappointed to have lost the patrol plane contract to Martin Aircraft Company, Fleet proceeded with the development of a civilian version of the Admiral. Hoping for a contract from Pan American Airways, the actual order eventually came from Ralph O'Neill's new airline, the New York, Rio, and Buenos Aires Line (NYRBA). The development of the Model 16 Commodore commenced in early 1929. Several can be seen here at the Buffalo factory.

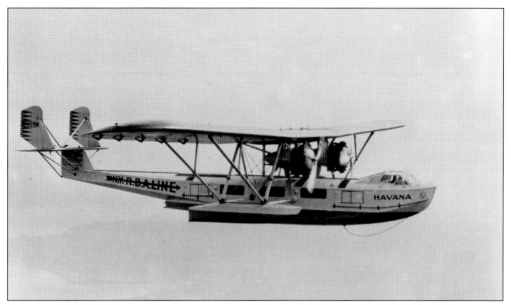

Fourteen Model 16 Commodores were eventually built, the first six for NYRBA, a joint venture between Fleet, Ralph O'Neill, and James H. Rand Jr. These safe and reliable flying boats could accommodate up to 32 passengers, and at least one remained in regular service until 1949.

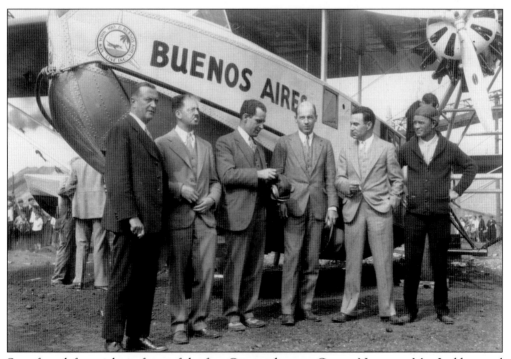

Seen from left to right in front of the first Commodore are George Newman, Mac Laddon, and Leigh Wade from Consolidated; Col. Ralph O'Neill, founder of NYRBA; Consolidated's general manager Larry Bell; and NYRBA's chief pilot, William Grooch.

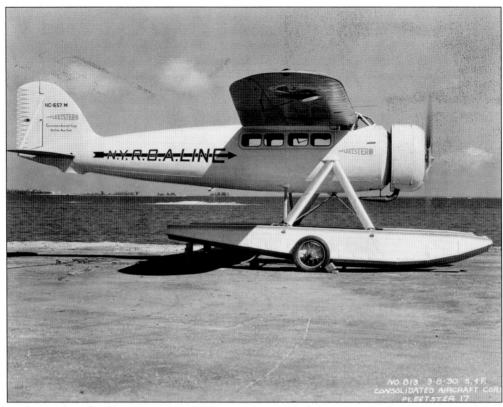

High-speed mail and passenger service contracts provided the incentive for the 1929 Model 17 Fleetster. While the plane resembled the contemporary Lockheed Vega, its fuselage was of all-metal construction. First flown by test pilot Leigh Wade in October 1929, the plane was operated off both wheeled and float landing gear. NYRBA used several, including NC657M seen here.

One Fleetster was built for the U.S. Army Air Corps as the Y1C-11 and was used as a staff transport flown by Capt. Ira C. Eaker. The success of this aircraft led to the acquisition of three more, designated as the Y1C-22. Standing in front of the Y1C-11 are Asst. Secretary of War F. Trubee Davison (left) and Eaker.

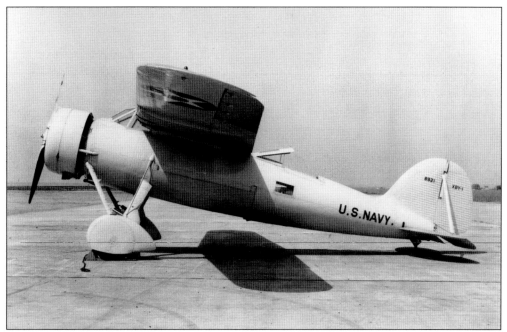

Another military version of the Fleetster was the Model 18, built for the navy as a two-seat, carrier-based naval bomber and designated the XBY-1. Delivered in September 1932, the plane had a relatively short life, being damaged beyond repair in a landing accident in April 1933. This photograph shows the upper gun position and the sliding bomb bay doors under the fuselage.

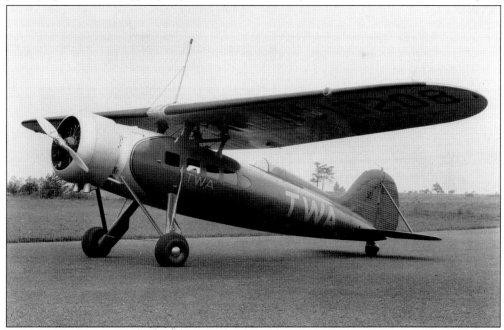

The Model 20 was a parasol wing version of the Fleetster and was first flown in the summer of 1930. In addition to mail and priority cargo, the plane could carry five passengers in its cabin while the pilot sat in an open cockpit behind the wing. While this innovative series proved reliable, only 26 were built, including this radio-equipped example for Trans World Airlines (TWA).

The Model 21 was designed in 1930 by Joe Gwinn for an army design competition to find a new primary trainer. The new design was purchased in small quantities by the U.S. Army as the PT-11. Also small orders by Colombia and Mexico were being built by Fleet in Canada, as Consolidated was occupied with their move to San Diego when the order was placed. Seen here is a U.S. Army Air Corps aircraft near Kelly Field in Texas.

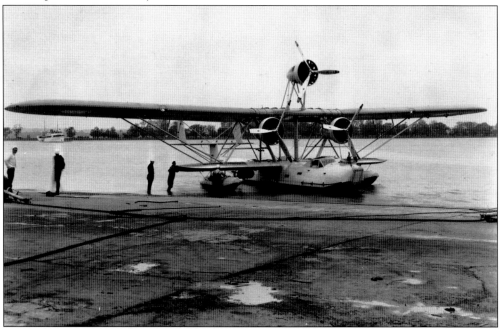

After the loss of the PY order to Martin, designer Mac Laddon went to work to improve the design. Based on his plans, a single prototype was ordered by the navy as the XP2Y-1 in May 1931 followed by a production order for 23 service models to be known as the P2Y-1 Ranger. First flown in March 1932 by test pilot Bill Wheatley, the pylon-mounted central engine was soon removed.

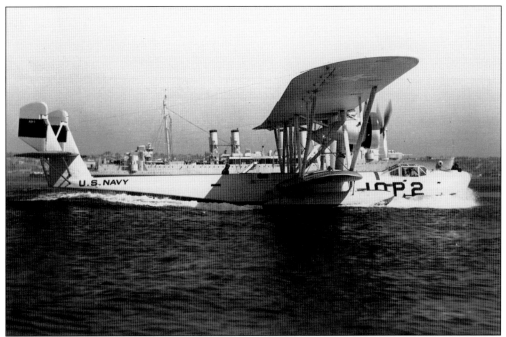

Taxiing on San Diego Bay after launching from NAS North Island is a P2Y-1 assigned to Patrol Squadron 10F. On January 10, 1934, six planes from this squadron completed a 14-hour formation flight from San Francisco to Pearl Harbor, setting a long-distance record. Copiloting the lead aircraft was a future admiral, Comdr. Marc A. Mitscher.

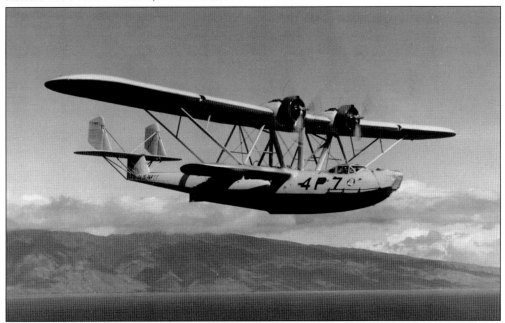

Popular in service with crew and maintenance personnel, 21 of the original production run were converted to the P2Y-2. The engines were moved into the leading edge of the wings and streamlining was improved to enhance performance. This aircraft was assigned to Patrol Squadron Four in Hawaii.

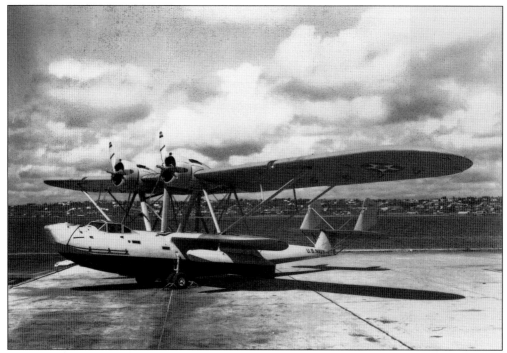

The final production version was the P2Y-3, which was similar to the P2Y-1 but featured more powerful engines and greater fuel capacity. Seen here is a newly delivered example on the seaplane ramp at NAS North Island on March 28, 1935.

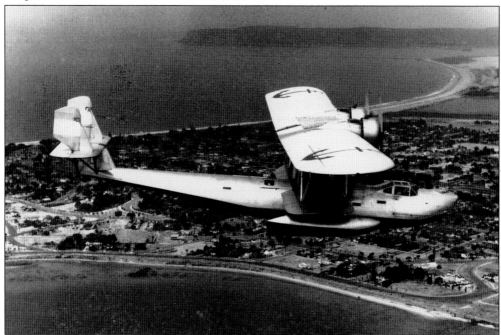

Eight P2Ys were produced for export. One P2Y each went to Colombia and Japan while six P2Y-3 flying boats were built for Argentina. The Argentine order was built in San Diego after the company relocated. Seen here is one of these in flight over Coronado before delivery.

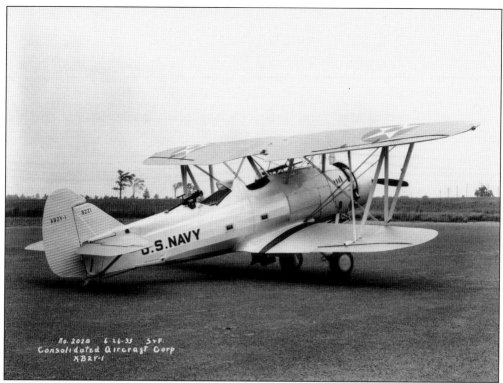

The Model 24 was built to meet a navy requirement for a new dive bomber in 1932 and designated the XB2Y-1. Designed in part by B. Douglas Thomas, the type was not successful and the contract went to the Great Lakes BG-1. The plane is seen here at the factory on June 26, 1933.

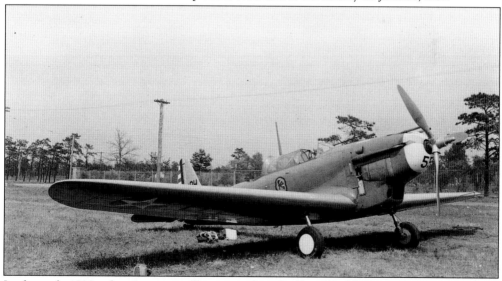

In the early 1930s, the army was still interested in the First World War concept of a two-seat pursuit plane with a rear-facing gunner. Consolidated offered the Model 25. By the time the army placed a production order for 50 planes, the company had moved to San Diego. Consequently, the first production airplanes to roll off the California line were these aircraft, now designated the P-30. This aircraft served with the 36th Pursuit Squadron at Langley Field.

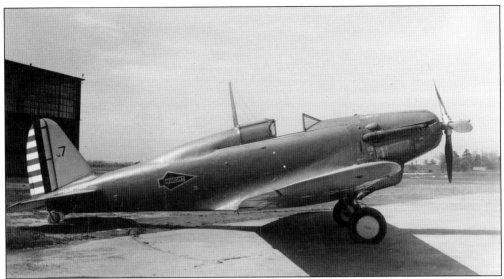

Even though the P-30 boasted many innovative features, the two-seat pursuit plane concept was obsolete by the time it was delivered. At high speeds, the gunner would black out as soon as combat maneuvering began, rendering him useless. However, the design did give Consolidated experience with all-metal construction, retractable landing gear, and turbo-superchargers. One P-30 was modified to single-seat configuration and is seen here under test at Wright Field, Ohio.

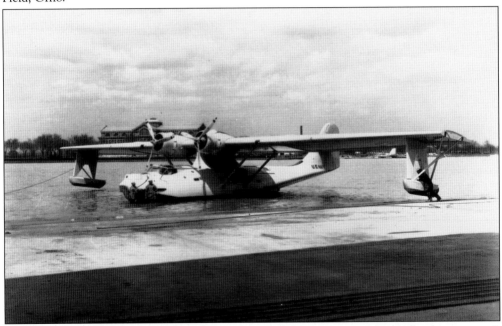

The last type designed at the Buffalo plant represented the strongest argument for the company's move west and would become the most famous flying boat ever built. Development of the Model 28 began before the P2Y entered navy service. Laddon wanted a more efficient design and used all-metal construction, creative innovations like retractable wing floats, and more powerful engines to achieve it. The Catalina prototype XP3Y-1 is seen here under test at NAS Anacostia on April 23, 1935.

Two
SUNNY SAN DIEGO

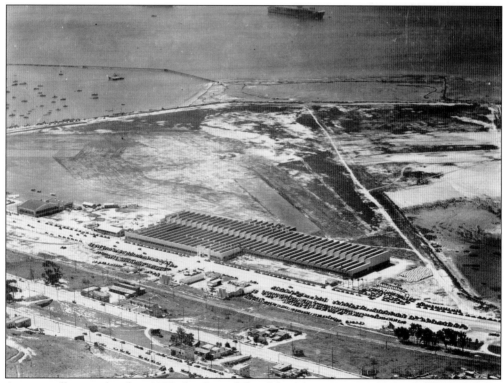

As originally completed in 1935, the Consolidated factory in San Diego covered some 247,000 square feet. Seen here on November 20, 1935, just after completion, it is clear that Lindbergh Field was still a grass strip and that most of the parking areas were not yet paved. The USS *Ranger* can be seen at anchor in San Diego Bay at the top center of the photograph. During the dedication of the new $500,000 factory on Lindbergh Field, Maj. Reuben H. Fleet said, "For twelve and one half years we have striven for this day. It marks the culmination of a dream for a factory of our own in a city of our choice."

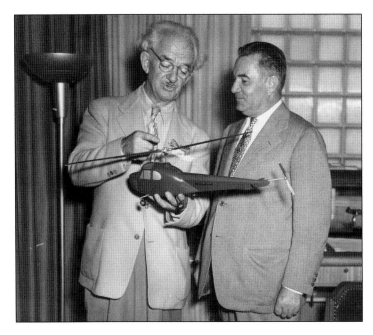

With the decision to relocate Consolidated to San Diego, Lawrence D. Bell, general manager of the company, decided to remain in Buffalo and form his own company. With Fleet's support, Bell formed the Bell Aircraft Corporation on July 20, 1935. He took over the former Consolidated plant along with many of its employees. The new company's first contract was to build outer wing panels for the PBY-1s. Seen here is Bell on the right. He would later become known for his rotary aircraft.

With the arrival of Consolidated in San Diego and the need for trained aircraft workers, the San Diego school system established a vocational course in aircraft work at the San Diego Junior College. The students spent half of the day at Ryan School of Aeronautics for their laboratory. Consolidated became the city's largest employer for the next half century.

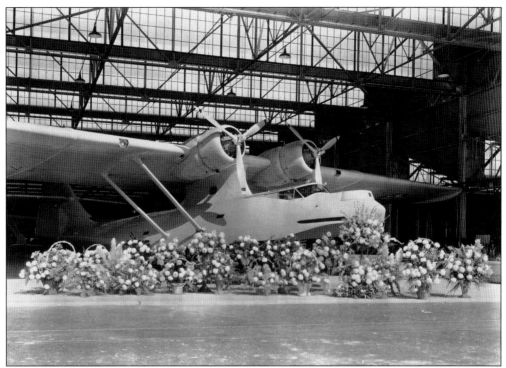

The city of San Diego really rolled out the welcome mat for Fleet and his company. On October 20, 1935, just days after finishing its record-breaking flight from Norfolk to San Diego, the new XP3Y-1 basks in the early morning sun behind celebratory flower arrangements dedicating the new factory. As many as 30,000 residents flocked to the airport for the ceremony.

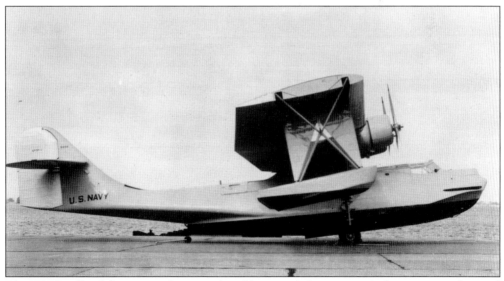

The XP3Y suffered from some directional problems, and the company's designers tested several tail shapes before settling on a production shape. In the days before computer simulators, this meant building full-size parts and actually flying with them. Seen here is an enlarged rudder with a straight trailing edge.

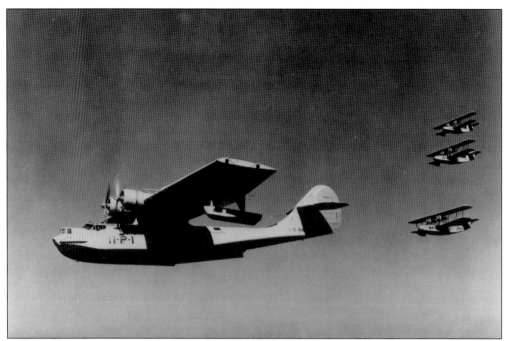

Eventually the designers decided on the tail seen in this photograph. The XP3Y-1 was issued to Patrol Squadron 11 in 1937 for service testing and was assigned to the squadron commander as 11-P-1. Note the pilot looking at the camera plane while resting his arm on the windowsill. As modern as the plane was, its cruise speed of 105 miles per hour was still pretty stately by the day's standards.

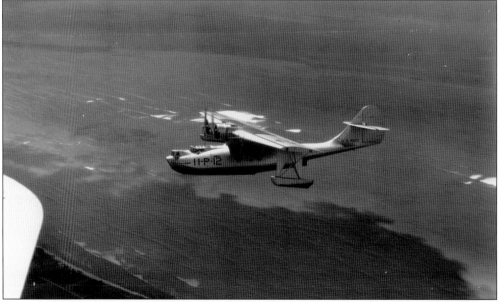

The navy decided to reflect the airplane's bomb-carrying ability in its designation and changed the nomenclature to PBY for the production versions. This stood for Patrol (P) Bomber (B) Consolidated (Y), the letter assigned to the company. The first production model was the PBY-1; the 60 built would be delivered to five squadrons, including Patrol Squadron 11, whose 11-P-12 is seen here over Coronado on July 27, 1937.

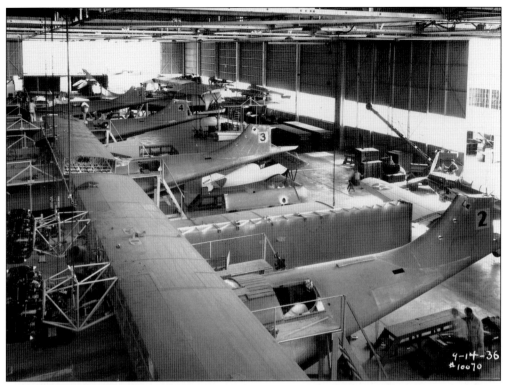

This photograph was taken on September 14, 1936, early in the PBY-1 production run, and shows the first five planes about a month before they were delivered to the navy. Illustrating the scope of production in the factory, a P-30A fighter can be seen behind an aircraft in the foreground and a Fleet 1 sport trainer can be seen in the center.

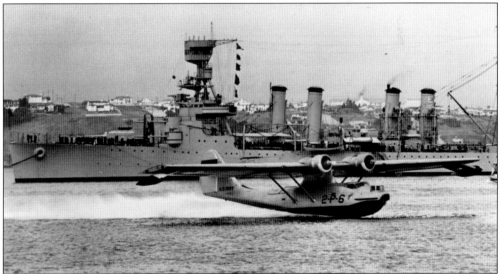

The next version in production was the PBY-2, fifty of which were built, and it differed from the PBY-1 in minor details and tail design. Taking off from San Diego Bay is a Patrol Squadron Two airplane on December 8, 1937. This photograph shows the wing floats in the process of retracting and an Omaha class cruiser in the background.

The navy required that each new flying boat be tested for water tightness. Always tempted to innovate with simple processes, the company decided that rather than float each hull and check the inside for leaks, they could just as easily pump water into each aircraft and check the exterior. This way, the hull did not have to leave the production line and the water could just be pumped from one plane to the next.

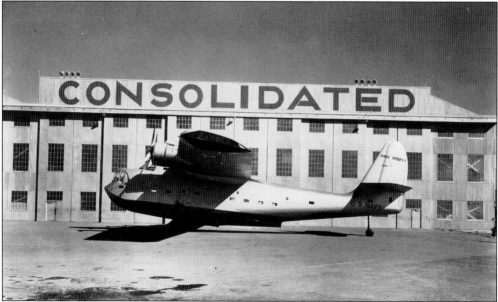

In May 1936, the navy awarded Consolidated a contract for a prototype of a four-engine flying boat. Mac Laddon's design, the Model 29, featured some of the same features pioneered on the PBY, like the retractable wing floats. The big plane made its first flight on December 17, 1937, and was designated the XPB2Y-1. Posed in front of the factory, the plane is seen here in its original configuration on December 7, 1937.

As with the PBY, the early PB2Y suffered from some directional control problems, which were first addressed with the addition of the oval-shaped auxiliary fins seen here on the horizontal stabilizers. The streaks visible on the fuselage are colored fluid released in flight to gauge airflow patterns. Eventually the entire tail unit was with the twin-fin design shown on page 47.

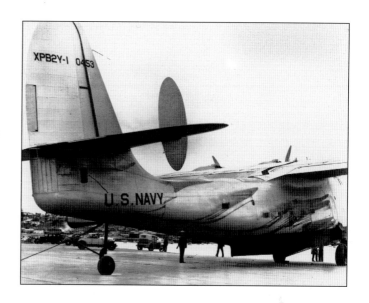

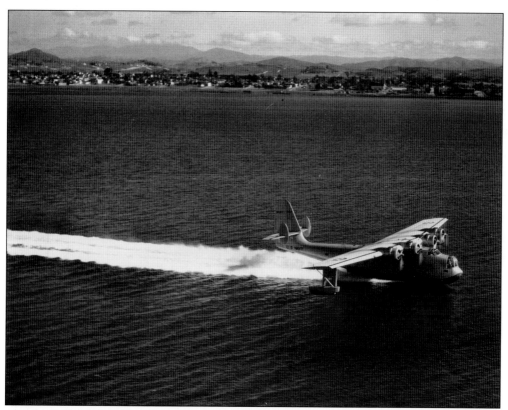

The elegant XPB2Y-1 skims across the water at the southern end of San Diego Bay. Designed as a potential replacement for the famous Catalina, the four-engined PB2Y series saw series production but not on the same scale as the PBY. During the war years, the prototype would be used as a VIP transport and was dubbed the "Blue Goose" after being painted overall gloss sea blue.

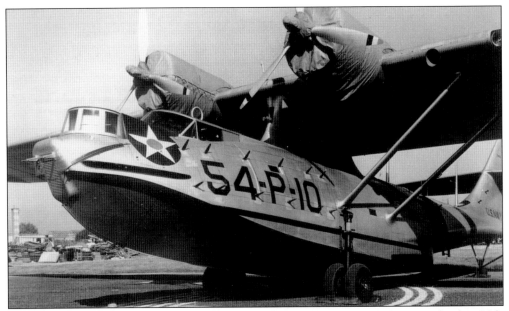

In 1941, a PBY-2 assigned to Neutrality Patrol with Patrol Squadron 54 became the first U.S. Navy aircraft to carry search radar. This photograph was taken at NAS Norfolk and shows the assorted aerials and masts associated with the installation.

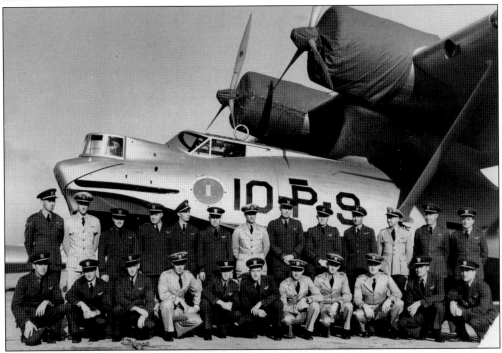

The PBY series participated in a number of record-breaking long-distance and formation flights, including one on January 18, 1938, which saw the 18 PBY-2s assigned to Patrol Squadron 10 take off from San Diego and fly nonstop to Pearl Harbor. This was the longest mass flight of naval aircraft ever undertaken at the time. The flight was commanded by Lt. Comdr. S. H. Warner, standing sixth from the right.

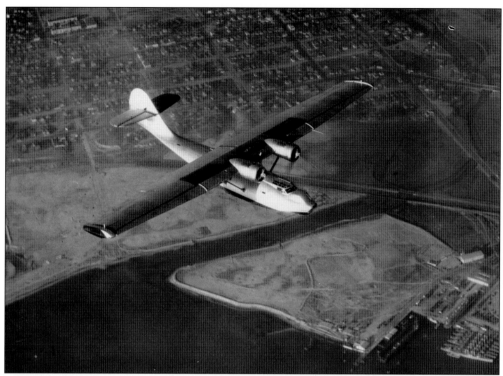

On January 9, 1937, the Soviet Union arranged to purchase three Model 28s as mail and cargo aircraft. The contract provided for three complete aircraft and manufacturing rights as well as technical assistance from Consolidated. The real reason for the purchase was to jump-start their flagging aviation industry, and the Model 28 was just one of a number of advanced western types acquired for the purpose. One of the completed aircraft is shown on a test flight over San Diego.

License production of the Catalina took place at a Soviet government factory at Taganrog on the Black Sea but was plagued by technical difficulties and proceeded very slowly. By the time the area was overrun by German troops in 1940, the factory had completed only 27 airframes. Known as the GST in Soviet service, this rare 1941 photograph was taken from an escorting U.S. Army B-18 and shows one in service with the Russian military.

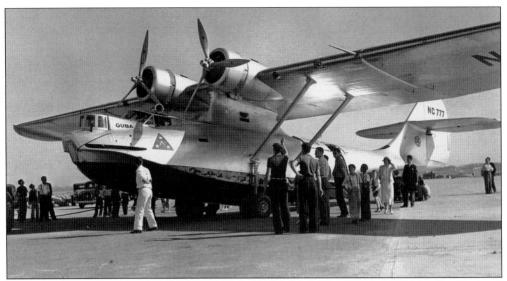

The range and load-carrying abilities of the big seaplane attracted the attention of Dr. Richard Archbold, an explorer and naturalist associated with the American Museum of Natural History. The first commercial Model 28 was built to his order for a proposed expedition to New Guinea. Named "Guba," the plane was ferried to New York to be prepared for its trip to the South Pacific. However, it was diverted to the Soviet Union to help search for missing polar aviator Sigismund Levaneskii but was unsuccessful. The "Guba" is seen here before leaving for New York.

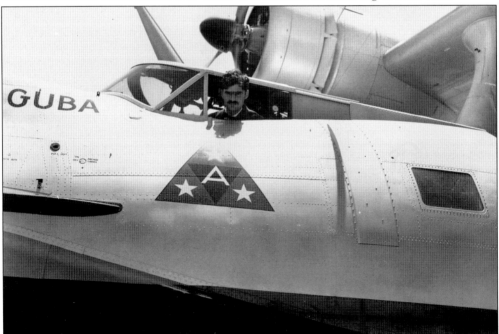

The first "Guba" was quickly replaced by another Model 28 named "Guba II." This aircraft had most of the improvements introduced by the PBY-2 and would go on to set many records for a seaplane while serving its intended purpose as a vehicle of exploration. Eventually it was handed over to the RAF, with whom it served during World War II. Richard Archbold is seen here in the cockpit of "Guba II."

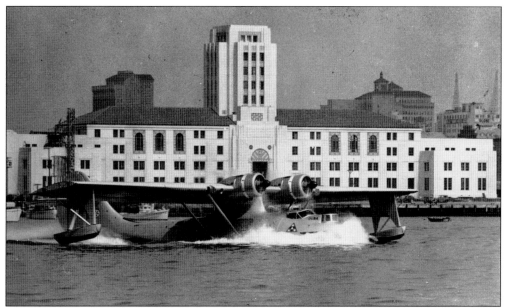

Richard Archbold's Model 28 Catalina taxis on San Diego Bay in front of the landmark county administrative building in December 1937. During 1938 and 1939, Archbold and his crew would complete the first flight around the world at its widest diameter, approximately at the equator. This flight included three firsts: 1) the first flight across Australia by a seaplane; 2) the first flight across the Indian Ocean by any airplane; and 3) the first flight across equatorial Africa by a seaplane.

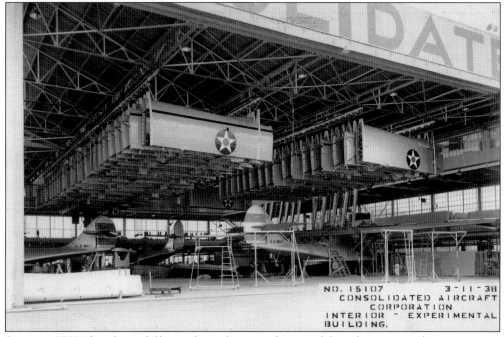

Sixty-six PBY-3 bombers, differing from the preceding model in their up-rated engines, were delivered between November 1937 and August 1938. Employment at this time was running at close to 3,700 people, and the company was showing good profits. This view shows the final assembly area at the factory on March 11, 1938.

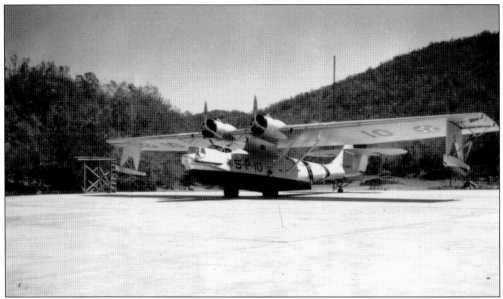

PBY-3s equipped Patrol Squadron Five in the Panama Canal Zone. The long ranging aircraft served the country's neutrality policy by patrolling areas near facilities of strategic national value. This image shows 5-P-10 sitting on the ramp at NAS Coco Solo. Most of the PBY-3s had been transferred to training duties by the time the Second World War started.

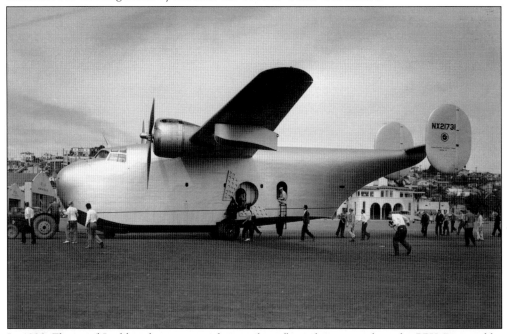

In 1938, Fleet and Laddon drew up new designs for a flying boat to replace the PBY. Powered by the Wright R-3350, the plane was developed without input from the navy. The deep-hulled plane would have a high aspect ratio wing designed by David R. Davis. Rather than wait for a navy order, Fleet proceeded to privately fund the construction of a Model 31 prototype, hoping for an order to follow but in part to test the Davis wing. This photograph was taken at Lindbergh Field after its first flight on May 5, 1939.

A combination of things led to the Model 31 never seeing production. However, development of the design continued until 1943, when the navy finally ordered 200 production P4Y-1 planes to be built at a government-owned plant on Lake Pontchartrain near New Orleans. Production never started owing to priority demands for the R-3350 to power the Boeing B-29. The prototype had been modified to near production status as seen here.

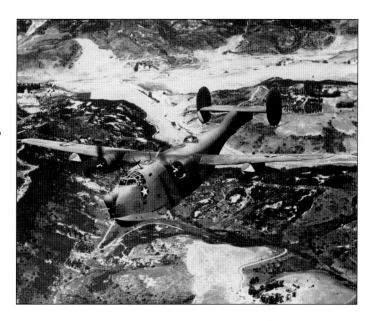

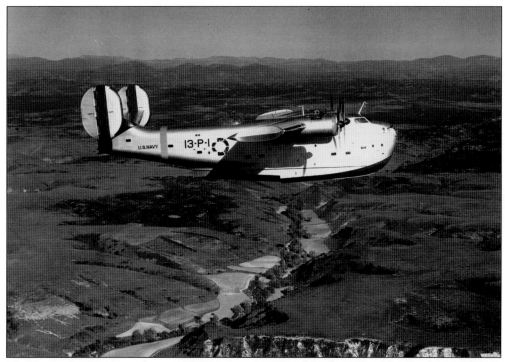

The first order for six production PB2Ys was received in March 1939, adding to Consolidated's already busy production lines. Called the PB2Y-2, these aircraft featured a redesigned nose and large twin-vertical tails. Lacking self-sealing fuel tanks and armor for the crew, these planes were not considered to be combat ready and were used instead for experimental purposes by Patrol Squadron 13 at NAS North Island.

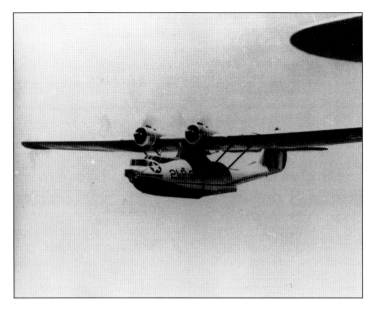

The PBY-4 introduced anti-icing equipment and even larger engines. Only 33 were ordered, and the last was briefly retained at the factory to be fitted with amphibious landing gear. Most of the PBY-4s were delivered to Patrol Wing squadrons based in the Philippines, where they would be overcome by the Japanese onslaught at the beginning of the Pacific War. This is a plane from Patrol Squadron 21.

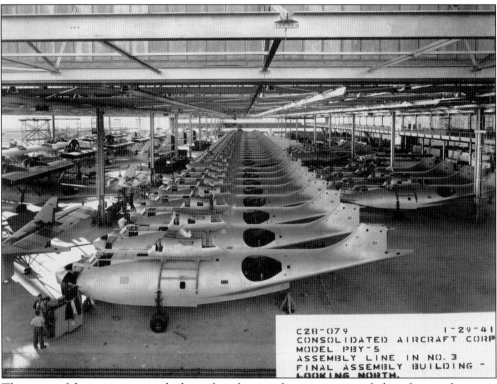

The successful experiments with the tail surfaces and waist positions led to their inclusion in the next of the PBY series, the PBY-5. This model also introduced another engine upgrade and several other improvements. A contract for 200 came in December 1939. This was the largest and most expensive naval aircraft contract since the First World War. Part of the production line for this contract can be seen in this January 29, 1941, photograph. Several aircraft for the first RAF order can be seen through the open factory doors.

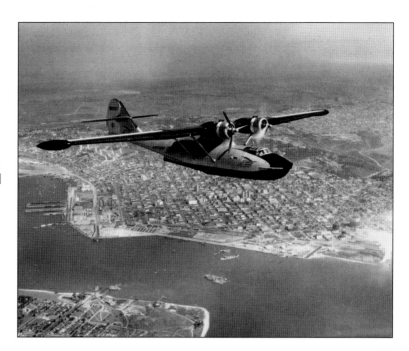

The last PBY to be built for a civilian customer was the Model 28-4 shown here. Ordered by American Export Airlines, it served as a route survey ship. Named "Transatlantic," the plane flew proposed routes for the company's Sikorsky VS-44 long-range passenger planes. It is seen here in June 1939 over San Diego Bay with the starboard engine feathered.

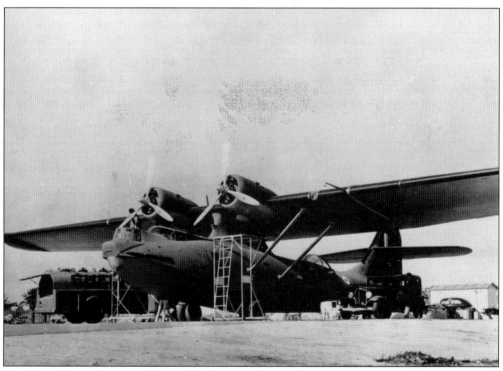

Based on the evaluation of a Model 28-4 in 1939 and an immediate need for aircraft, the RAF ordered 30 of the Model 28-5ME. Similar to the PBY-5, these aircraft differed mainly in equipment and self-sealing fuel tanks. The order was quickly increased to 50, with other contracts following soon after. The RAF used a name system for its aircraft instead of the navy's alphanumeric process. They dubbed the type "Catalina," and the name stuck.

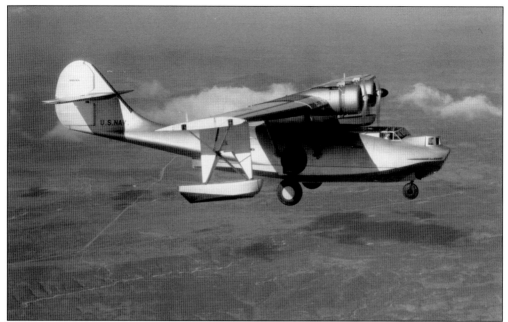

Late in 1939, the last PBY-4 was converted to an amphibian with the addition of retractable tricycle landing gear. Redesignated the XPBY-5A, this aircraft was delivered to the navy at NAS Anacostia for testing. The success of these tests and the added utility offered by the ability to land on airfields led to orders for 770 PBY amphibians from San Diego alone.

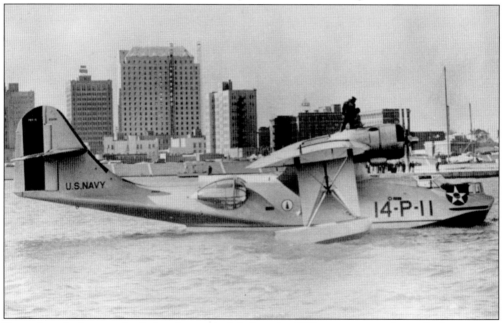

Even though the navy had already concluded that the PBY was nearing the end of its service life and more modern types were already under development, it was equally clear that war was looming on the horizon and nothing else was likely to be ready soon. Consequently, between December 1939 and the outbreak of war, the Bureau of Aeronautics placed orders for 476 PBY-5s and PBY-5As. These were immense orders by prewar standards.

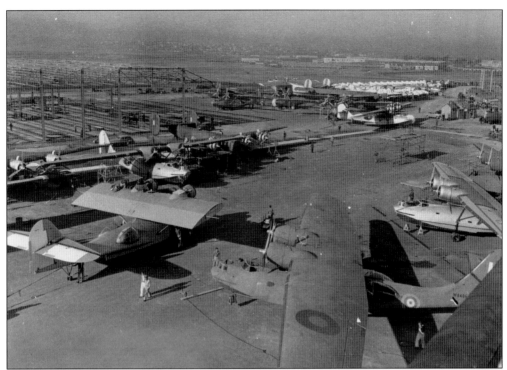

The RAF was desperate to supplement its long-range sea search capabilities, and the PBY seemed the best choice at the time. The British named the plane the Catalina after the resort island off the Southern California coast, and this name quickly came to be used almost universally. The first production RAF Catalina is seen in the foreground of this December 1940 photograph.

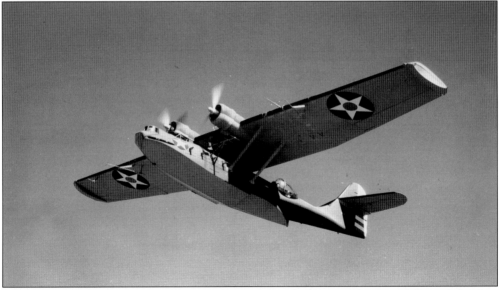

Shortly after the first contracts for PBY-5s were signed, the navy instructed Consolidated to paint the airplanes in two-tone gray camouflage in place of the colorful silver and yellow peacetime color schemes. The aircraft in this 1940 predelivery photograph also carries a full array of radar aerials.

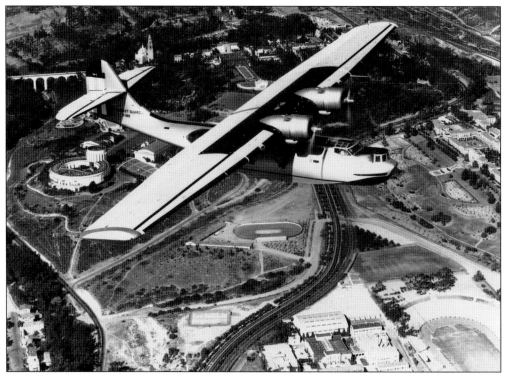

One of the first PBY-5s off the line was diverted to the U.S. Coast Guard and is seen here over San Diego's famous Balboa Park on October 22, 1940. The USCG would operate PBY aircraft continuously until the last was retired in 1956. Visible under the tail of this photograph is the Ford Building, currently the home of the San Diego Air and Space Museum.

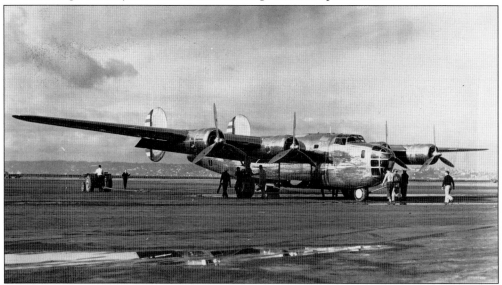

In 1939, the Army Air Corps suggested that Consolidated might build the Boeing B-17 under license, but Fleet's team believed that they could design a superior plane and developed a proposal. The Army Air Corps liked the concept and granted a contract on March 30, 1939, for the first B-24. By December 29, 1939, in less than nine months, the prototype was ready for flight.

While the Model 31 was not a resounding success, many of its design features were used to create the Model 32. Its tricycle landing gear, twin tails, wing design, and flight deck were all used to speed the B-24s development. The XB-24 was used as a flying test bed for the rest of its career, eventually being dubbed "Gran'pappy," seen here with factory test crew.

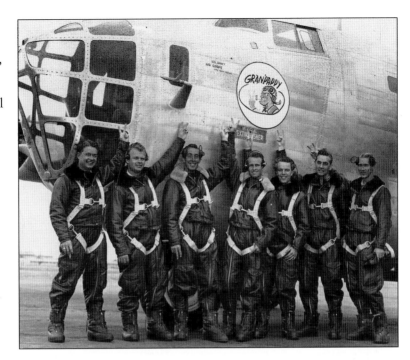

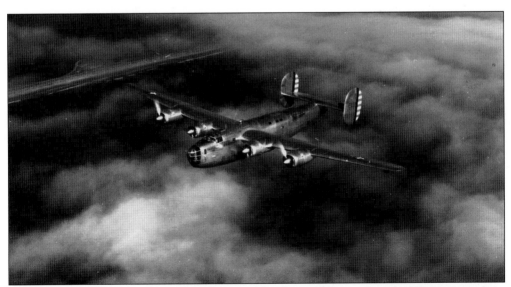

Showing off its elegant Davis wing and experimental propeller spinners, the XB-24 is seen here on an early test flight over the Silver Strand near Coronado. So promising was the design that before the first flight even took place, the army had already placed contracts for 45 additional aircraft. Ultimately, more B-24s would be built than any other single American combat plane.

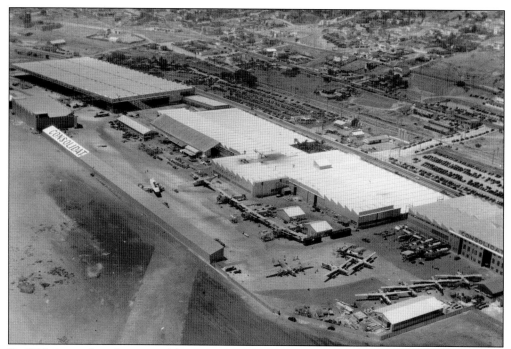

By 1938, it was clear the original factory space was not going to be sufficient to accommodate new contracts; a building expansion began. An additional 450,000 square feet of building space was added. Also, over 170,000 square feet of pavement was laid out between buildings to provide space for final assembly outside. This aerial view taken May 7, 1940, shows the completed facility with all six PB2Y-2s, the Model 31, the XB-24, six LB-30As for the RAF, one PBY-4, and two PBY-5s.

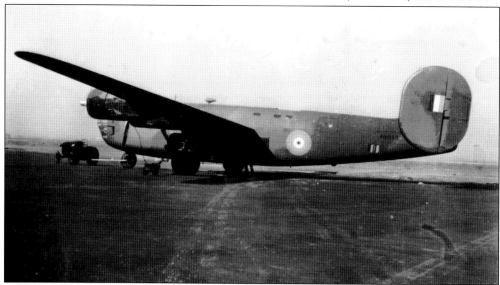

While testing of the prototype XB-24 was still under way, the French Purchasing Commission placed an order for 175 aircraft to be designated LB-30. France fell to the Germans before any aircraft were actually built, and the RAF took over 135 aircraft on the contract after specifying dorsal and tail power turrets, armor, and self-sealing fuel tanks be provided. The second airplane to be delivered, AM259, is seen here before the installation of armament.

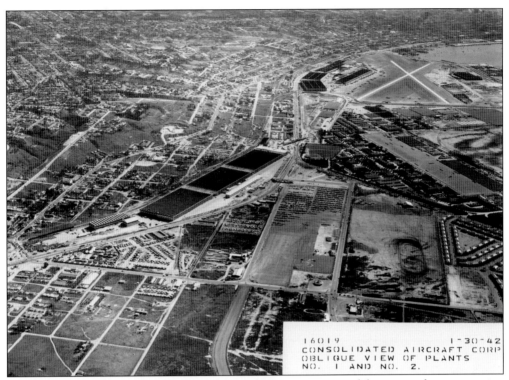

In spring of 1940, largely because of new B-24 and PBY contracts, work began on a huge expansion plan to increase the production space available by over 600,000 square feet. The cost of the expansion was largely covered by the government's new Emergency Plant Facilities provision. The new Building Two is seen here on January 30, 1942, shortly after completion. Within weeks, work would begin to camouflage the building against the possibility of enemy air attack.

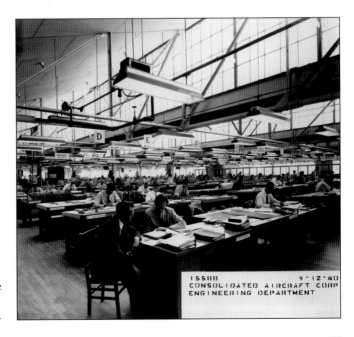

This September 12, 1940, photograph shows a portion of the engineering department. The man power required to make an aircraft business successful in the 1940s was immense, and the talents required were very specific. These people were all professional draftsmen; electrical or mechanical engineers; or power plant, instrument, weapons, or design specialists. Most had college degrees or graduated from one of the aviation trade schools that had begun to appear during the Depression.

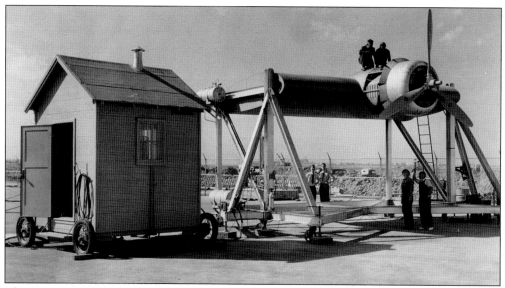

The proper installation of engines was almost an art form. It required technical ability and quite a bit of experience. In most cases, the aircraft manufacturer worked closely with the engine maker to ensure the engine would function properly. This September 15, 1940, photograph shows a group of engineers using the engine test stand to check a Pratt and Whitney Twin Wasp installation. The test shack and rig were set up on the factory ramp outside Building One.

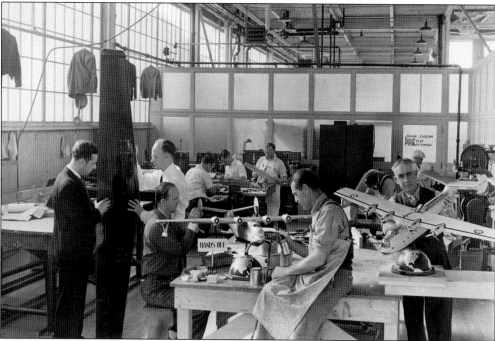

This image shows the interior of the model shop at Plant One in 1940. Model shops were an important part of the aviation industry at the time. In addition to display and presentation models like the two PB2Y-1s in the right foreground, the shops built wind tunnel models for testing in an age without computer simulations. The two men on the far left are examining a wind tunnel model wing. Consolidated would begin construction of its low-speed wind tunnel in 1943.

Three

CONSOLIDATED GOES TO WAR

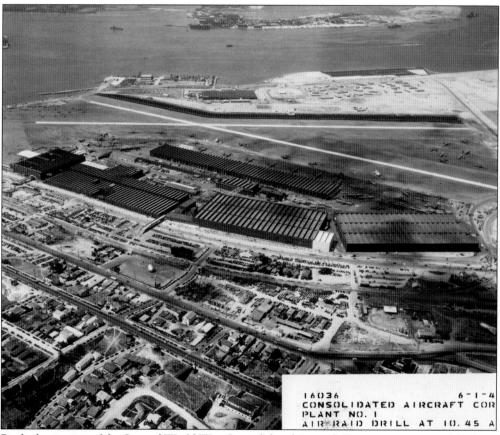

16036 6-1-4
CONSOLIDATED AIRCRAFT COR
PLANT NO. 1
AIR RAID DRILL AT 10.45 A

By the beginning of the Second World War, Consolidated Aircraft Corporation operated facilities in 13 U.S. cities and had contract personnel in Taganrog, Russia. Expansion continued with the onset of the war, as the aircraft industry became the largest single industry in the United States. The enormous aircraft production contracts required a tremendous mobilization of machine tools, labor, and production engineering. Consolidated produced such aircraft as the PBY and B-24. In San Diego alone, Consolidated produced 6,726 of the 18,482 total B-24s built for the war. The company emerged from the war era as one of the largest-producing aircraft companies in the nation.

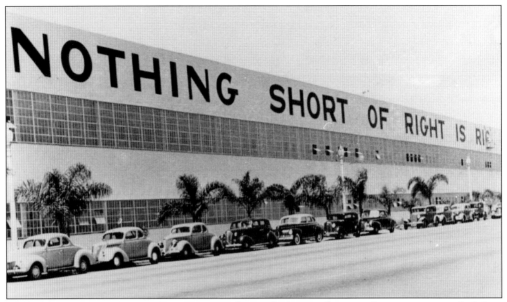

The company's aircraft earned an exceptional record of strength, ease of maintenance, reliability, and safety. Fleet's dedication to perfection was apparent in his motto, "Nothing Short of Right is Right," painted in large letters on Plant One in San Diego in 1941.

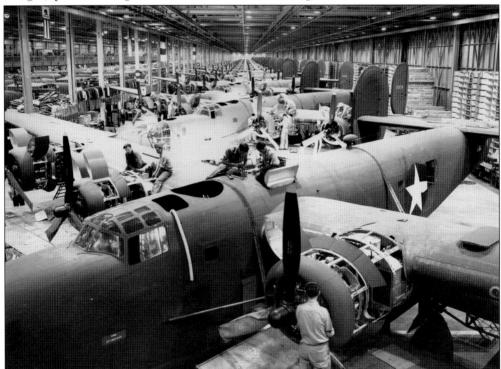

By the time the United States entered the Second World War, Consolidated production was already in high gear. U.S. and foreign orders for B-24s, PBYs, and PB2Ys already amounted to over 2,000 aircraft, and their delivery was critical to the war effort. The aircraft in this early 1942 photograph are B-24D bombers.

After the surprise attack on Pearl Harbor, San Diego was considered a potential target for enemy attack. The city quickly mobilized to defend itself and the coast. Camouflage nets were used to hide major aircraft manufacturing facilities. Seen here is the lumber storage area on March 6, 1944. The buildings were painted in camouflage paint. Visible atop the main portions of Plant Two are camouflage netting, a false house roof, and fake trees.

As the war progressed, the need for aircraft workers increased. In a response to a request from the Office of Production Management in Washington, D.C., Reuben H. Fleet announced that Consolidated would start a program to train and employ women in manufacturing aircraft. The work included light mechanical operations and machine and precision assembly work. Preference was given to wives and relatives of men already employed at Consolidated. In September 1941, Consolidated hired 40 women as an experiment, assigning them to the San Diego plant building B-24s.

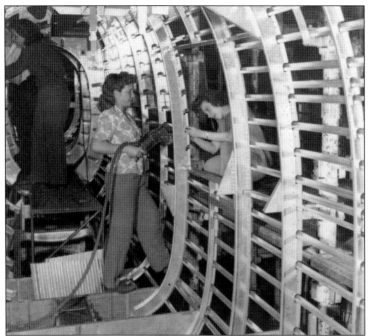

Two women install rivets on a B-24 at the San Diego Consolidated Aircraft plant. Such women workers inspired the famous sobriquet "Rosie the Riveter." By 1943, employment of women at Consolidated reached about 40 percent. Many people remarked, "These are the girls who are keeping 'em flying."

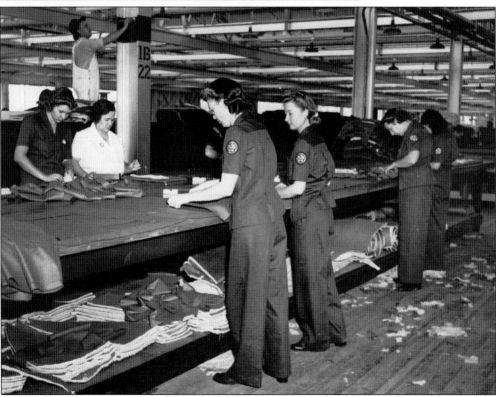

These women work in one of the fabrics departments at Consolidated in 1942. They are piecing together insulating material to be attached to the insides of B-24 bombers. Later in the war, the trim uniforms and badges gave way to more conventional clothing.

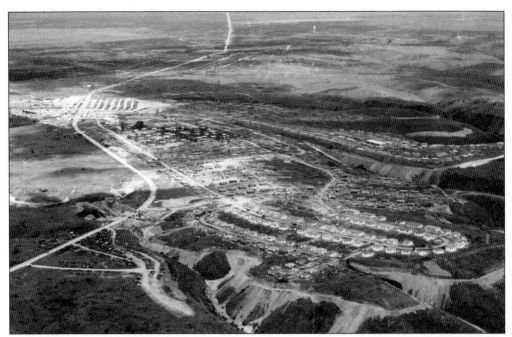

Eventually local help ran out and Consolidated recruiters looked outside San Diego, traveling as far as the East Coast. The population boomed in San Diego as people relocated to meet the demands of the aircraft industry. Employment at Consolidated's San Diego plant increased from 4,744 employees in February 1940 to 45,190 in February 1943. To address the housing shortage in San Diego, the federal government approved construction of 3,000 units of public housing on a plateau northwest of Mission Valley. The project was entitled the Linda Vista Defense Housing Project.

Discouraged by the government involvement in the aircraft industry, Fleet decided to retire. He sold his shares to Vultee Aircraft Corporation in March 1943. The two merged companies became known as Consolidated Vultee Aircraft Corporation, later Convair. Both companies had been operating independently under the umbrella of the Aviation Corporation. Seen here is founder of the Vultee Aircraft Corporation, Gerard "Jerry" Vultee.

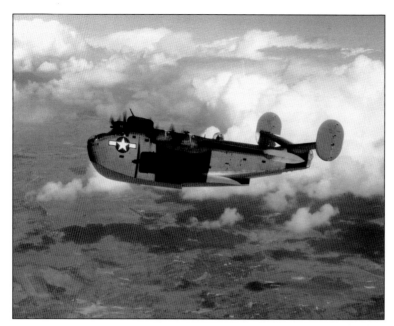

Wartime production of the PB2Y series continued with 200 PB2Y-3 flying boats. However, wartime equipment like power turrets and radar had led to significant increases in weight, and the aircraft was now seriously underpowered, so provision was made for Jet-Assisted Take-Off (JATO) rockets. Little use was made of the aircraft in combat.

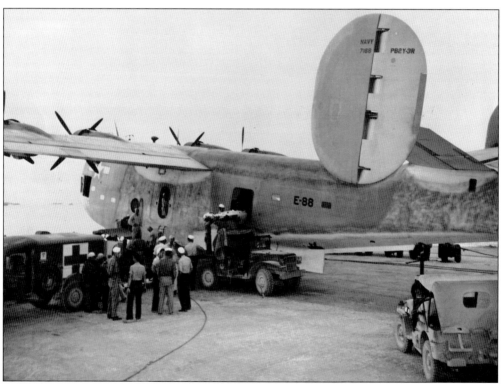

Rohr Aircraft Corporation converted a significant number of PB2Y3s into PB2Y-3R and -5R transports. These aircraft had larger engines and mounted shorter diameter four-bladed props on the inboard power plants so that they would clear the fuselage. With seating for 44 passengers and provision for up to 16,000 pounds of cargo, these aircraft saw widespread use in the Pacific theater. The aircraft in this photograph is serving as a hospital evacuation aircraft.

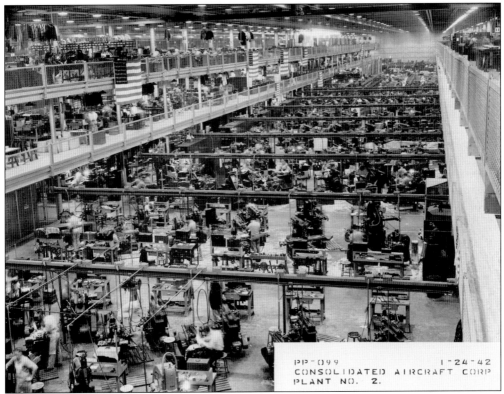

Taken from one of the galleries in Plant One, this January 1942 photograph of part of the production hall shows workers and machines on the ground assembling subcomponents for various aircraft. The second floor was used as a staging area for small parts. The third floor was the domain of engineers and draftsmen.

The war years saw the PBY in service with virtually every ally in every theater of the war. Consolidated had accommodated anticipated servicing needs with standard maintenance platforms that could allow easy access even though permanent facilities were not readily available.

Black Cat operations in the Pacific were among the many famous combat roles for the PBY. Operating at night and painted overall black, the Catalinas of 14 squadrons sank 112,700 tons of merchant shipping and damaged another 47,000 tons and at least 10 Japanese warships between August 1943 and January 1944. This photograph shows a Black Cat getting some much needed maintenance during the day.

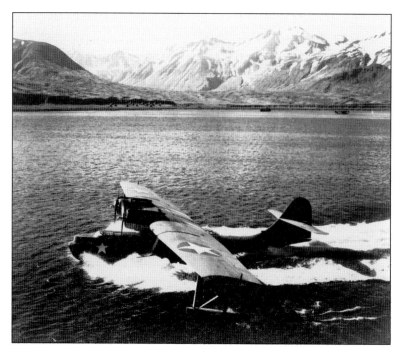

Equally at home in the freezing snow and fog of the Aleutian Islands as the South Pacific, Catalinas provided the reconnaissance needed to retake Attu and Kiska from the invading Japanese forces. Servicing was often provided by the navy's fleet of seaplane tenders when improved bases or amphibious PBY-5As were not available.

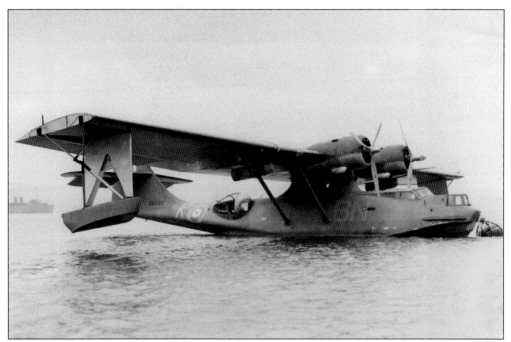

The RAF made good use of the Catalina's strengths. On May 26, 1941, one of their Coastal Command Catalinas, with an exchange USN commander among its RAF crew, located the German battleship *Bismark*, leading to its ultimate sinking by the British fleet. The aircraft in this photograph, a Catalina II, serial AM269, carries depth bombs under the wings.

Nicknamed "Dumbo" because its two waist blisters resembled oversized ears, the Catalina was possibly most famous for its use as a rescue plane. Seen here during an exercise on San Diego Bay, a Coast Guard crew demonstrates the techniques that would be used on a calm body of water.

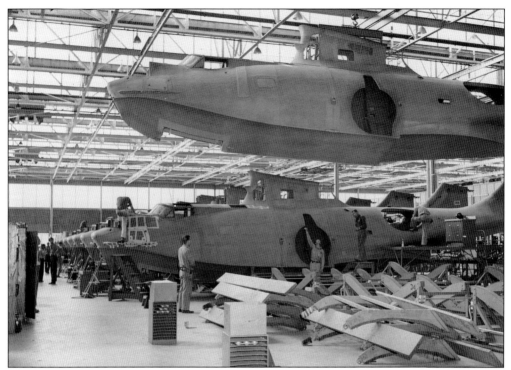

Production of the PBY was complex but largely automated. In this November 1941 view of PBY-5As, the third airplane in line would be the first World War II USN aircraft to attack a submarine. On February 17, 1942, while serving with VP-73, it made an unsuccessful bomb run on U-352.

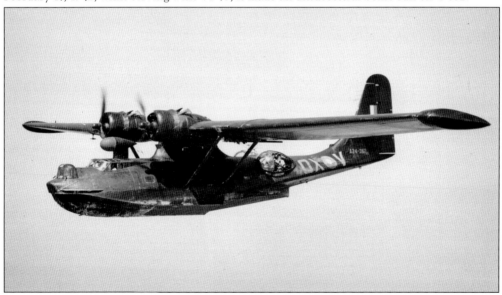

Demand for the Catalina was so great that it was produced at five factories in North America. Boeing established a production line in Vancouver, British Columbia, where the type was built as the PB2B. Most of the production from this facility went to air forces of Australia, Great Britain, and New Zealand. Seen here is a PB2B-2 from the Royal Australian Air Force serving with No. 43 Squadron.

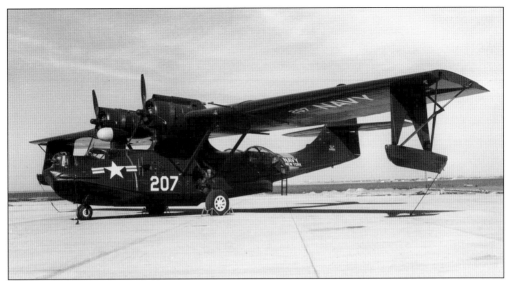

The final Consolidated production version of the PBY was the PBY-6A, 175 of which were built at a government-owned plant near New Orleans, Louisiana. The last aircraft rolled off the production line in September 1945, bringing to an end 10 years of continuous production. The type remained in service with U.S. forces until 1956 and continued to serve into the 1970s with smaller countries.

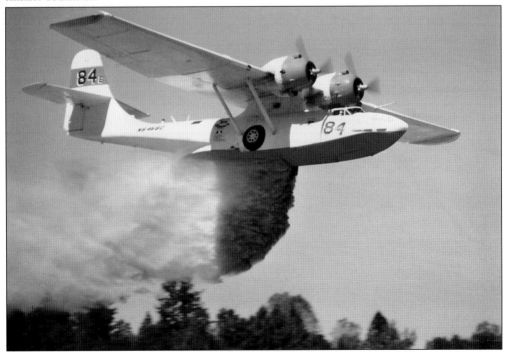

Well after they had served their time in the military and had finally been declared obsolete, the Catalina continued to serve. Used as airliners, cargo planes, aerial survey platforms, film stars, executive aircraft, and fire tankers, about 100 exist today, many as prized museum exhibits and others as privately owned "war birds." This photograph shows PBY-6A N6456C making a demonstration drop.

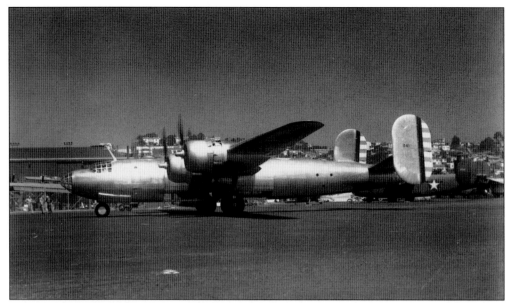

Even as the B-24 entered full-scale production, the Army Air Force was looking for its replacement. The requirement called for a greater bomb load, higher speed and altitude, and cabin pressurization. The two types selected for development were Consolidated's B-32 and the Boeing B-29. The first XB-32 would not be ready to fly until September 1942.

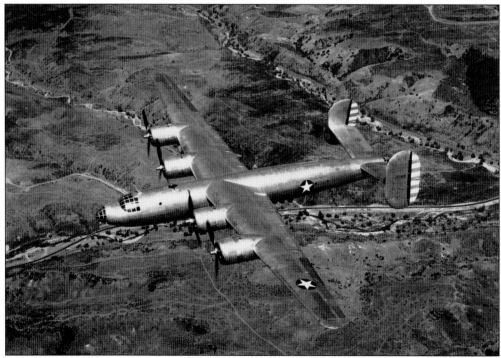

Problems with the remotely controlled gun turrets and pressurized fuselage caused the first plane to be delivered almost six months late. Worse yet, after only 30 flights, the prototype crashed during a take-off attempt on May 10, 1943, and the second aircraft was not ready until July. It is seen here during a test flight over San Diego County that summer.

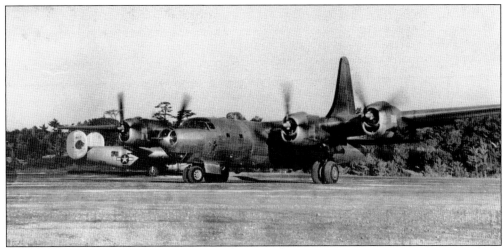

The USAAF soon decided in favor of the B-29, but since its test program was also lagging, the B-32 continued under development as a potential back-up. Production versions abandoned the troublesome pressurization and carried manned turrets. Production took place exclusively at the Fort Worth plant, where 114 were built, with the type seeing limited service in the Pacific late in the war. One is seen here preparing to take off from Okinawa.

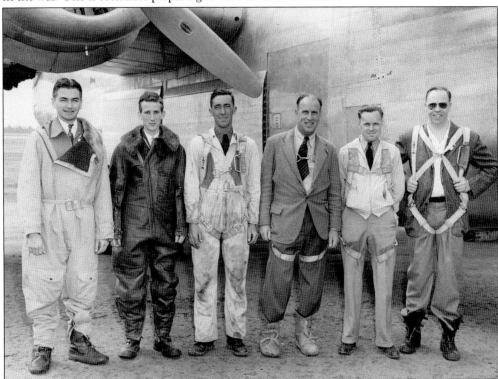

The original prototype B-24 continued in use as a developmental test plane throughout the war years. It was eventually modified into the XB-24B. The flight crew for the XB-24B's test flights in January 1942 included, from left to right, Bill Chana, N. Thomas, J. McEachern, Doug Kelley, Freddie Zellmer, and D. Moore. Bill Chana has been involved with the San Diego Air and Space Museum for decades.

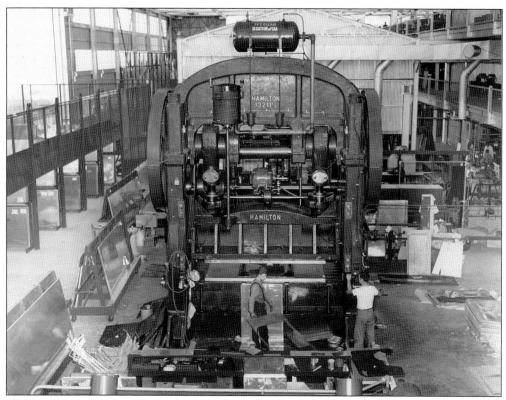

This huge drop hammer was used to pound out thousands of identical metal parts for use in the aircraft. The factory produced most of the basic aircraft components on site, with subcontractors providing certain subassemblies complete and ready for installation. For example, Pratt and Whitney engines, Hamilton Standard propellers, Goodyear tires, Bendix radios, and ERCO gun turrets came by rail from contractors all across the country.

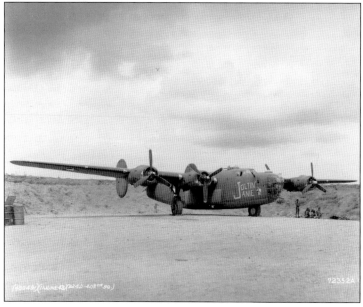

The B-24 was built in at least 18 different production versions for the Army Air Force. The first major subtype to see combat was the B-24D, of which some 2,738 were produced. Assigned to the 43rd Bomb Group, 403rd Bomb Squadron, "Joltin' Jane" is seen here at its dispersal in Mareeba, Australia. This aircraft was eventually lost in a landing accident on August 20, 1943, near Port Moresby, New Guinea.

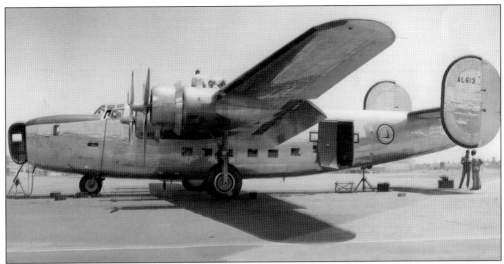

The army received 75 LB-30s in exchange for earlier aircraft delivered to England from USAAF contracts. Most of these planes, like AL613, were converted to long-range transports and served throughout the various theaters of the war, hauling priority cargo and passengers. Based on the cargo experience with the LB-30, the USAAF ordered over 280 C-87s. These aircraft served as the army's primary heavy transport until the introduction of the Douglas C-54. The planes could accommodate up to 25 passengers, and many were used on the "Hump" missions in China.

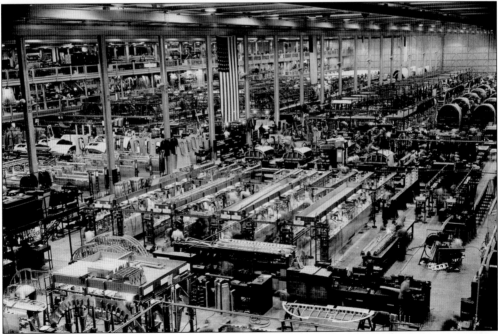

Developing a process of converting raw materials and subcomponents into complex flying machines was nearly as daunting a task as designing the planes themselves. Moving all of the parts together was something like orchestrating a delicate ballet. The right pieces had to come together at just the right time or everything could come to a screeching halt. This January 1942 view shows workers assembling B-24 rudder assemblies in the foreground while fuselage sections take shape in the rear.

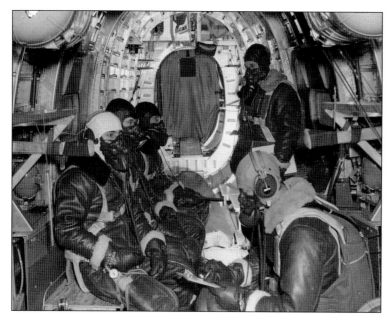

Testing aircraft performance in the stratosphere was done on the ground in a high altitude chamber at the San Diego plant. Seen here, the crew wears electrically heated suits under their coveralls, electrically heated felt boots, rubber overshoes, helmets, electrically heated gloves, oxygen masks, and headphones.

Dr. A. R. Sweeney, assistant flight surgeon, looks into one of the heavy glass ports to observe the crew during the flight. This is a rear view of the altitude chamber, showing the relative size of its companion freezing chamber and a portion of the compression equipment.

In April 1942, Gen. H. H. Arnold decided to open a regular service between the mainland and the Southwest Pacific. The Ferrying Command chose Consolidated as the operating agency. The wartime air cargo/passenger line became known as Consairway. When the airline closed in 1945, it was reported to have carried more than 101 million ton-miles of cargo and had flown more than 299 million passenger miles.

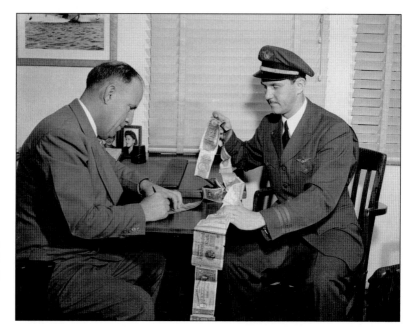

Doug Kelly signs pilot George Oberdorf's "short snorter" on March 8, 1945. A "short snorter" is a chain of foreign paper currency taped together end to end. The longer the "short snorter," the more countries one had visited. Obviously, Consairways pilots visited a lot of countries.

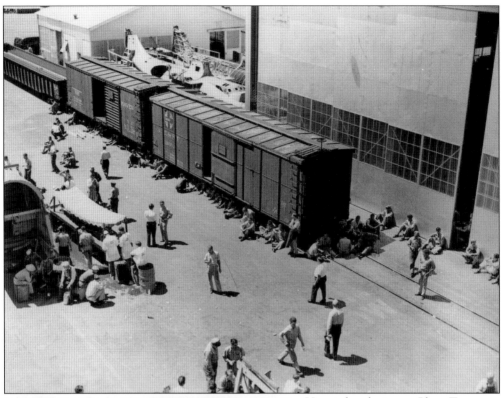

Here is break time at Plant Two during the summer of 1943. The plants were short on creature comforts for the workers. As can be seen here, shade and seating were both at a premium. The Atchison, Topeka, and Santa Fe Railroad Company train tracks ran directly along the south side of the factory, so sidings for receiving raw materials and components from subcontractors was very convenient. Note the PBY fuselages located behind the train cars.

Margarita Pauletto was among the many women employed by Consolidated during the war years. She is seen here operating a drop hammer in department 205 in November 1943. Equipment like this massive tool had been the exclusive domain of men until the demands of war made it clear that other measures needed to be taken.

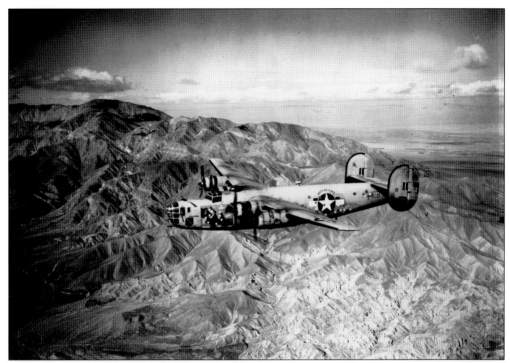

B-24D from the 98th Bomb Group, 343rd Bomb Squadron—"The Squaw," serial number 41-11761—was a veteran of the famous August 1943 Ploesti raid. The airplane returned to the factory on a war bond tour before being reassigned to training duties. Placed on display at the factory, thousands of employees and city residents viewed her and other products of the company.

During the war years, Consolidated's employees participated in many war drives and morale-building contests. One was a sort of lottery called "Work-to-Win," and this photograph shows Mr. and Mrs. Ralph W. Morrow in January 1944 after winning $1,000 that month. Both were employed at the factory.

This unidentified employee is attaching control cable to the wing of a Liberator. Plants operated eight-hour shifts a day, seven days a week. Throughout the war, childcare and housing were problems.

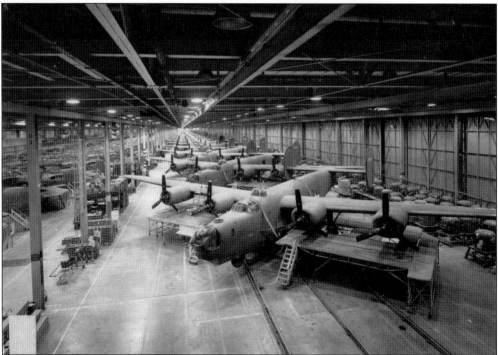

The B-24 Liberator was built in larger numbers than any other U.S. combat aircraft of World War II, with total production reaching 18,482. This image taken in the San Diego plant's Building Four shows the final assembly line for B-24J models in January 1944. The noses on the line to the left of the photograph are moving away from the camera while the nearly finished planes on the right are moving toward it. Built in larger numbers than any other subtype, 6,678 B-24J bombers were built, 2,792 at San Diego.

B-24J Serial No. 44-41064 was the 5,000th Liberator to be built at the Consolidated plant in San Diego. Signed by hundreds of workers who helped to assemble the aircraft, it went on to serve in Italy with the 15th Air Force and survived the war only to be scrapped in the United States in 1946. It is seen here ready for delivery.

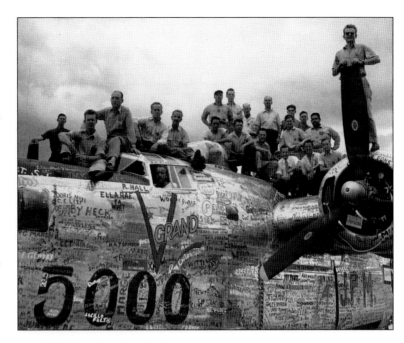

This B-24 was named for a movie. The film *Winged Victory* (Twentieth Century Fox, 1944) was directed by George Cukor and starred Lee J. Cobb, Jeanne Crain, and Judy Holliday. The story is about six cadets during basic training, perilous bombing missions, and the wives who waited for them. Actress Jeanne Crain (second from left) has just signed her name under "Winged Victory," a new B-24 Liberator on its way to the combat zone.

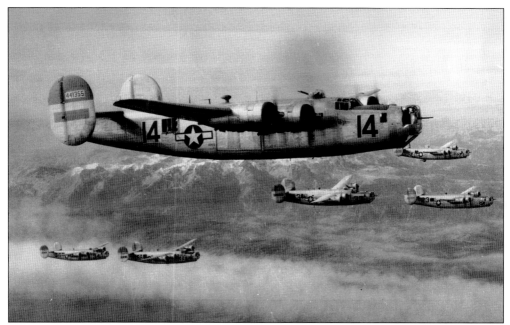

The San Diego–built B-24J was serial number 44-41355, of the 764th Bomb Squadron/461st Bomb Group, based at Torretto Field, Italy, 1944. This aircraft survived the war and brought its crew home to the United States in 1945. As the war progressed, camouflage became less important than weight and speed. Subsequently, most late-production aircraft were delivered in natural metal.

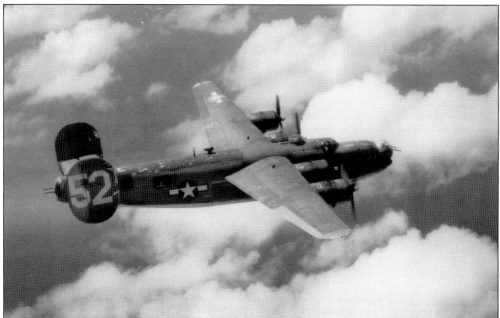

The long-range, speed, and load-carry capabilities of the B-24 led to navy orders for the type as a long-range patrol bomber designated the PB4Y-1. While early aircraft were exactly the same as their USAAF counterparts, later aircraft were delivered with naval equipment, search radar, and different nose turrets. These aircraft served in the patrol and shipping interdiction role in the Pacific theater as well as convoy escorts and U-boat killers in the Atlantic.

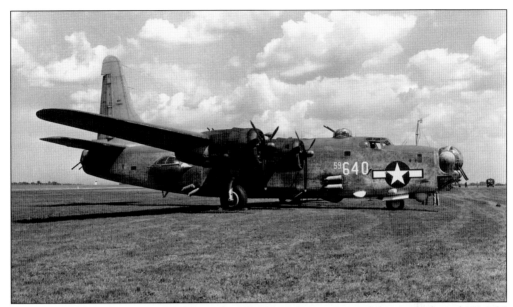

The successful experience gained from the PB4Y-1 and army tests of the single-finned YB-24N led to the development of a purely naval version. Although designated the PB4Y-2, this was an almost completely new design with a completely redesigned fuselage, tail, and engine nacelles. After extensive late-war combat duty, these aircraft served well into the postwar era, not leaving navy service until 1962. The aircraft in this photograph carries JATO bottles.

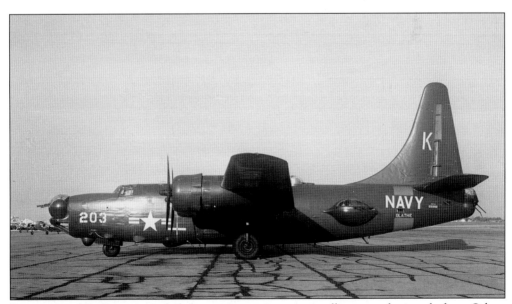

Postwar use of the Privateer included extensive service as an intelligence gathering platform. Others served with the Coast Guard or, like this NAS Olathe–based aircraft, with the Naval Reserve.

In addition to serving the navy, a number of surplus Privateers found their way onto the civilian registry, where they were used extensively as fire bombers. Modifications included the removal of armor, electronics, and weapons equipment as well as the installation of a large tank for fire retardant. The former Coast Guard aircraft in this photograph was operated by Hawkins and Powers Aviation.

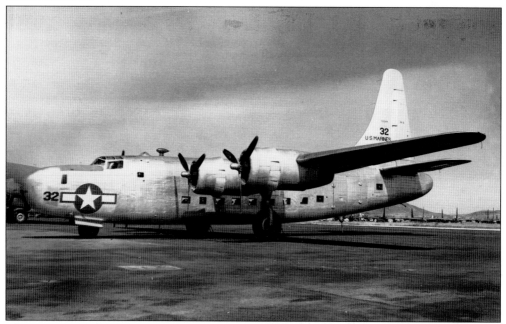

The navy received 34 RY-3 transports based on the PB4Y-2. The airplane had an all-new fuselage married to the wings and tail of the patrol bomber. Several served with the Marine Corps, like Bureau No. 90044, seen here at Marine Corps Air Station Miramar in late 1945.

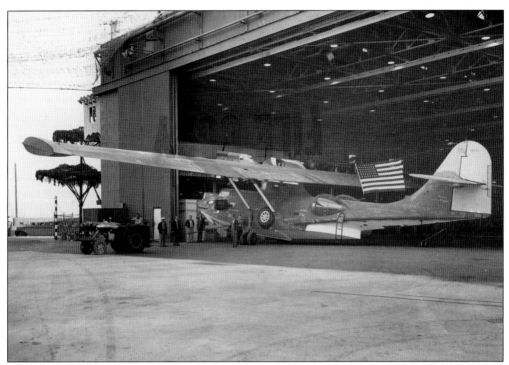

By the time the last San Diego–built PBY rolled off the assembly line on March 27, 1944, the home factory had delivered 2,159 Catalinas. Seen here as it rolled out into the San Diego sunshine, Bureau No. 46579 was signed by many of the assembly-line workers as the plane made its way through the plant.

With full-scale production of the B-24 under way, Consolidated continued to work to improve the type. They installed a single fin and rudder on a B-24D in 1943, and its successful test led to the XB-24N. The single fin offered less drag, better control, and a better field of fire for the upper gun turret. However, although originally selected for production, the end of the war in Europe led to the cancellation of contracts after only seven had been built at the Willow Run, Michigan, plant.

Consolidated started development of a very heavy bomber to meet an AAF requirement for a bomber that could carry 10,000 pounds of bombs 5,000 miles and return at 35,000 feet and 240–300 miles per hour without refueling. Consolidated Model 37 was the winning design, and two prototypes were ordered in April 1941. Shown here is a 1942 wind tunnel model showing the early twin-tailed configuration.

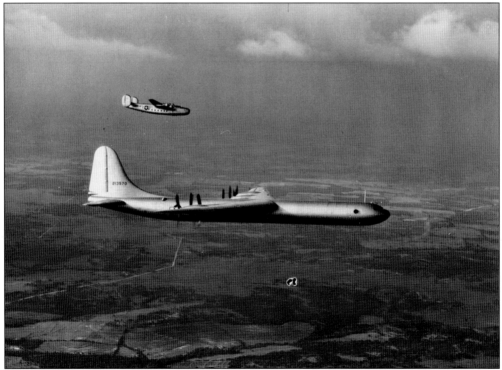

Because of the priority of B-24 and flying boat production, the B-36 project was reassigned to the Fort Worth factory as the design work was nearing completion. Seen here in company with a C-87 photo ship, the XB-36 dwarfed anything else then in service. Its 230-foot wingspan makes it the largest aircraft ever to serve with the U.S. armed forces.

In an effort to shortcut the process of designing a new cargo plane, Convair used the wings and tail unit of the PB4Y-2 married to a new fuselage in designing the Model 39 Liberator-Liner for a proposed navy contract. The navy decided against the design, but Convair hoped to sell it commercially and formed a brief partnership with American Airlines to run a three-month cargo service with the type in late 1945.

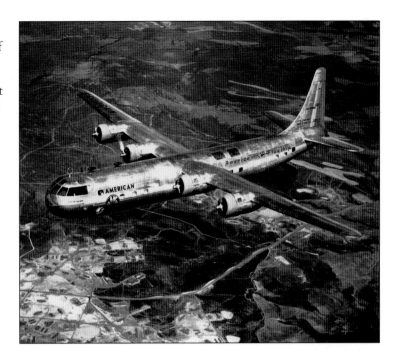

Several interesting Convair projects in other cities during the late war years were supported by various departments at the San Diego plant. One of these, designated the TBY-2 Sea Wolf, was the licensed production of a Chance-Vought–designed torpedo bomber developed as a competitor to the Grumman TBF Avenger. Limited production took place at a new factory in Allentown, Pennsylvania.

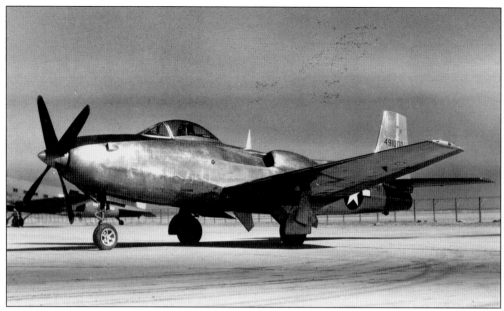

Another interesting project was the mixed-propulsion XP-81. Built at the Vultee facility in Downey, California, this plane was to have been powered by a turboprop nose engine with a jet engine in the rear. Two aircraft were produced and tested at Muroc AAB in 1945. However, the mixed power setup was rendered obsolete by the rapid development of jet engines, and the design was shelved.

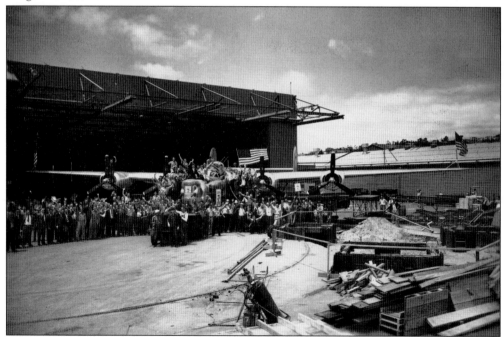

The last of 6,726 B-24s to roll out of the San Diego plant was this B-24M, serial number 44-42722. While the event was celebrated by the factory workers seen here, there was bad news. The B-32 contract had been cancelled, and the B-36 production was to be diverted to the Fort Worth plant. For the first time in 10 years, Consolidated San Diego was running out of aircraft to build.

Four

AN INDUSTRY LEADER

The end of the Second World War brought wholesale cutbacks in production at all of America's defense industries. Convair was not immune, and layoffs began even before the war actually ended. From a peak of 45,000 workers in 1943, the company shrank to 35,000 in early 1945. By 1945, the workforce stood at 3,760! Many of these same experienced people would soon be back at work for the aerospace industry as the cold war began to heat up. Slowly Convair began to prosper again, building small planes like the Stinson-designed Model 108, L-13 observation plane; larger commercial air transports such as the Convair-liner series and the jet-powered 880 and 990 series; as well as military aircraft like the Seadart, Pogo, Tradewind, Delta Dart, and Delta Dagger.

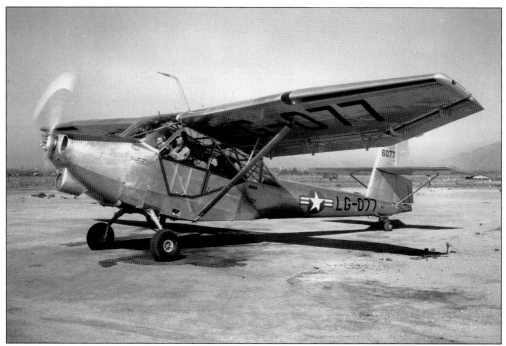

Designed as a replacement for the famous L-5 liaison plane by the Stinson Division, the L-13 was the first plane to go into postwar production at San Diego. While the two prototypes were built at the Wayne, Michigan, plant, all 300 production machines were built at San Diego.

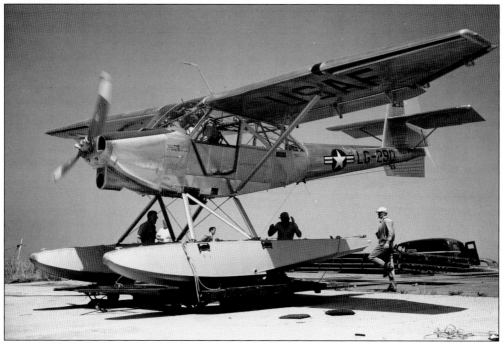

Operated by both the army and air force, the L-13 was versatile and easy to maintain, serving until declared obsolete in the mid-1950s. After military service, a number were sold on the civilian market and found use as bush planes. This aircraft is shown mounted on floats.

In 1944, the AAF issued a requirement for a jet-powered tactical bomber. Mac Laddon and his team offered the Model 109 design. Four prototypes were ordered, but the war's end led to contract cancellations and cutbacks, including many advanced designs. Work eventually finished on one aircraft, given the air force designation XB-46. First flown on April 2, 1947, it is seen on a test flight from Muroc AFB.

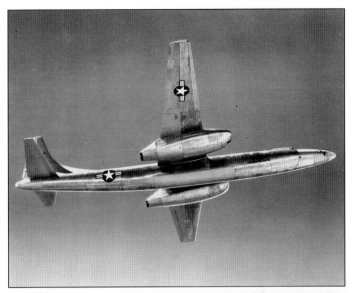

The competition for the XB-46 was a classic. Boeing's B-47 featured swept wings and was as well streamlined as the Convair design. During its flight testing, the USAF assigned Capt. Glen Edwards to lead the project. Edwards was later killed testing the Northrop YB-49 flying wing design, and Muroc AFB was renamed for him. He is seen here (second from left) in front of the XB-46. This one-of-a-kind aircraft took off for the first time on April 2, 1947, from Lindbergh Field, San Diego.

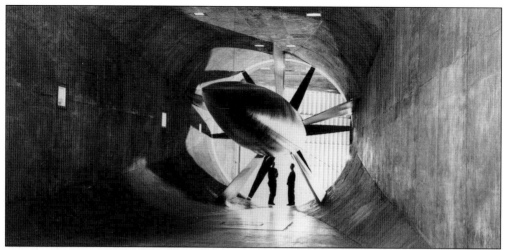

The Convair Low Speed Wind Tunnel began operations under the direction of Consolidated Vultee (Convair) in May 1947, located at Lindbergh Field off of Pacific Highway (south of the main plant). The tunnel has been used in numerous military and civilian aerospace development programs, including the F-106, B-58, F-111, F-16, Global Hawk UAV, Tomahawk Cruise Missile, and Advanced Cruise Missile. The facility is now known as the San Diego Air and Space Technology Center Wind Tunnel.

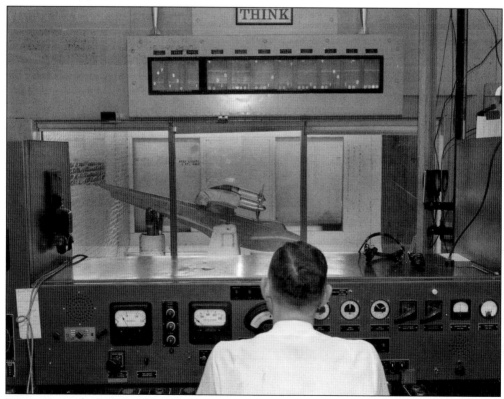

Engineers watch through a window in the control room into the testing area of the wind tunnel. Model aircraft are placed in the cross-sectional area of the tunnel to conduct low-speed flutter testing and other flight characteristics.

Designed to replace the Douglas DC-3, work began in early 1945 on the 30-seat Model 110. The plane featured tricycle landing gear and other safety features not found on prewar designs. It also used exhaust-thrust augmentation to improve performance. Seen here on July 17, 1946, just nine days after its first flight, the Model 110 proved the concept but was not large enough and did not feature the pressurization potential customers were going to be looking for.

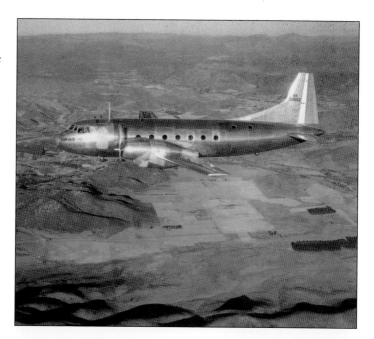

The company's largest postwar civilian aircraft success story started with the Model 110. Seen at the plant during final assembly on June 24, 1946, are Mike Alianelli, ? McNeal, and Roy Sims. Alianelli would later be a Convair retiree association member and a 15-year volunteer at the San Diego Air and Space Museum.

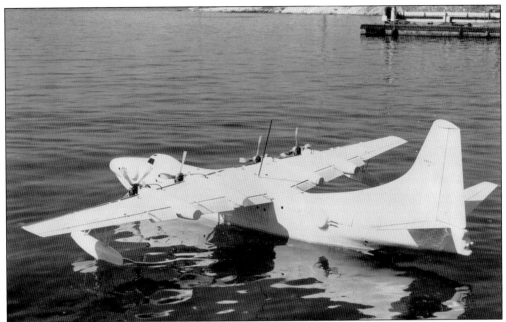

During the war years, Consolidated founded the Hydrodynamic Research Laboratory (HRL) to develop advanced flying boat hulls. After the war, captured German research was used to advance the process. Using a combination of large water tanks and remote-control models, the lab under the direction of Ernest G. Stout developed several advanced hull shapes, including that for the XP5Y seen in this 1947 photograph.

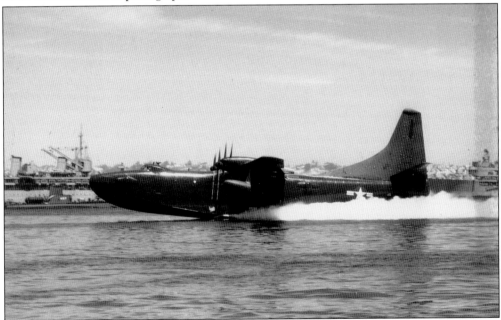

In answer to a late-1945 navy requirement for an advanced patrol flying boat, Convair developed the Model 117. Using research data from the HRL and experimental Allison turboprop engines, the plane was originally designated the XP5Y-1, and two were ordered by the navy in 1946. Development delays with the engines meant that the first flight would not take place until April 1950.

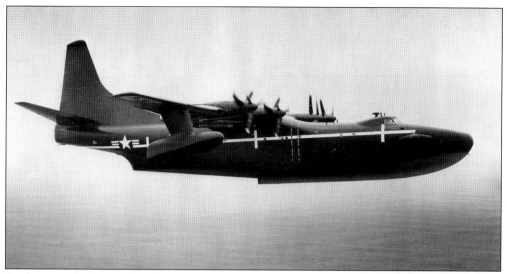

By the time the XP5Y flew, the navy was reevaluating the continued need for seaplanes in the patrol and antisubmarine role. The contract for the Model 117, now named the Tradewind, was modified to change the role of the aircraft to that of transport; the navy designation was changed to R3Y. The already protracted development of the type became even longer, but flight testing continued with the original prototypes while redesign took place.

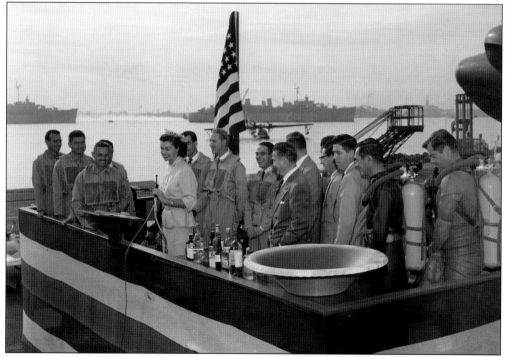

Convair had high hopes for the transport version of the Model 117 Tradewind, so much so that the rollout of the prototype of the R3Y was attended by actress Esther Williams on December 17, 1953. With her on the platform is test pilot Don Germeraad, representatives of the navy and Convair, and members of the rescue team. The bottles arranged on the table contained water from all seven principal seas of the world and were poured into the basin for the christening.

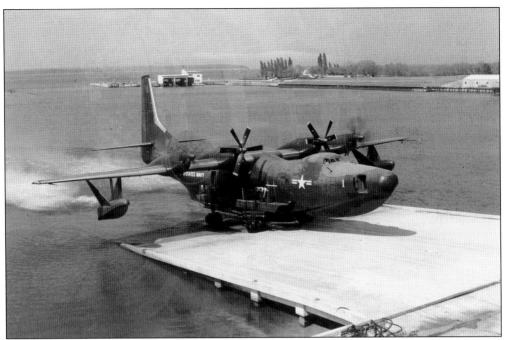

Convair designed an ingenious self-contained beaching cradle that allowed the Tradewind to taxi up onto a ramp under its own power, as seen here. In 1955, a Tradewind set a world record for seaplanes that still stands today. It flew from San Diego to Patuxent River, Maryland, at an average speed of 403 miles per hour.

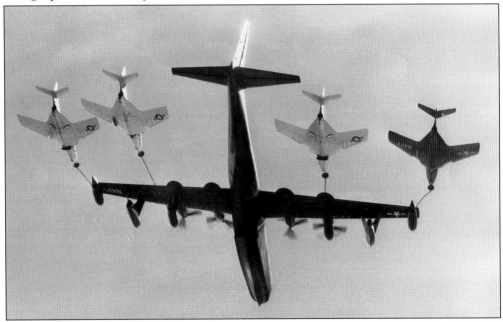

In a bid to give the Tradewind more utility to the navy, several of the R3Y-2s were given air-to-air refueling capabilities. Sadly, the days of the flying boat as a naval platform were already numbered. This and continued difficulties with the troublesome engines and gearboxes led to a short career for the R3Y.

In answer to Boeing's new B-52 bomber, a jet version of the B-36 was proposed in 1950. The YB-60 was given newly designed swept wings and tail surfaces, although the fuselage was largely the same as the B-36F. The large number of common parts and assemblies meant the new design went from design to first flight in only eight months. Two were built at the Fort Worth plant, but only one flew. As it was quite a bit slower than the B-52, plans for production were shelved and the two prototypes scrapped.

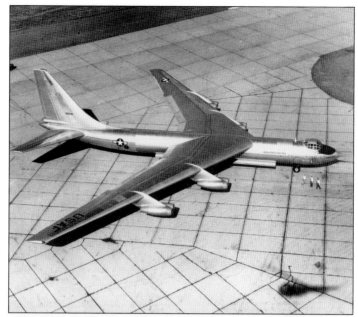

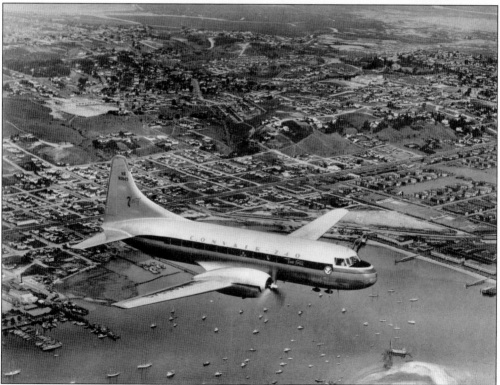

The prototype Convair 240 flies over Point Loma and San Diego Harbor on its way back to Lindbergh Field in March 1947. The Model 240 was a private company venture intended as modern replacement for the famous Douglas DC-3. With its tricycle landing gear, pressurized fuselage, and powerful engines, the plane found a ready market, with 171 being built. This success led to the development of Models 340 and 440 and significant contracts from the air force and navy.

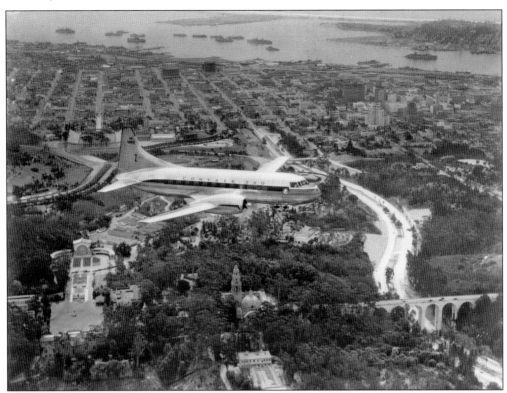

The first great design to come out of Convair during the postwar era was the Model 240 "Convair-liner." Design started in late 1945 using the concept proven by the Model 110. Built to seat 40 passengers in pressurized comfort, it was easy to maintain and capable of cruising speeds in excess of 280 miles per hour. At least 10 airlines and the USAF were customers for 566 of this model built. The prototype, seen here over famous Balboa Park, first flew on March 16, 1947.

The air force and navy operated various models of the Convair-liner, including a trainer version called the T-29. This 1953 photograph, titled "Bathing Beauty," was taken as part of an advertising program. Unfortunately, the model's name is unknown.

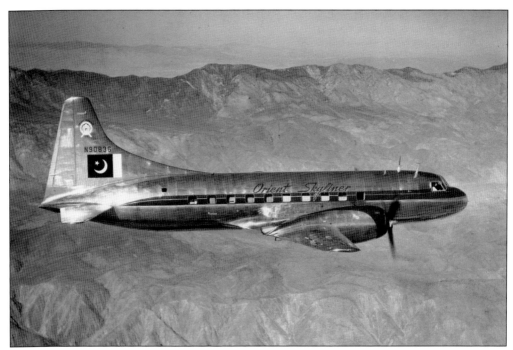

This aircraft is one of three Convair 240s to be purchased by one of the smaller customers for the type, Orient Airways, Ltd., a small feeder airline operating in Pakistan. In 1955, this airline was merged with several other small carriers to form Pakistan Airlines.

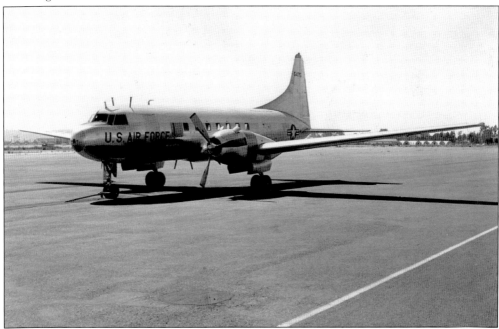

The Convair C-131 was a militarized version of the Model 240 and was delivered new to the U.S. Air Force and U.S. Navy. However, in service, it was one of those elite airplanes that served with every branch of the armed services and the Coast Guard. The aircraft in this photograph is the first C-131A delivered, serial number 52-5781.

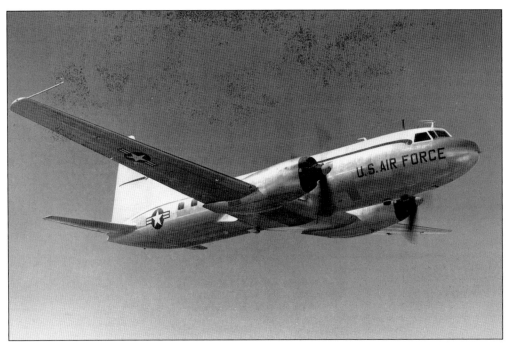

In 1954, two C-131s were ordered with Allison turboprops in place of the original Pratt and Whitney Double Wasps. Designated YC-131Cs, these aircraft gave the USAF its first practical experience with turboprops and served as test beds for engine development.

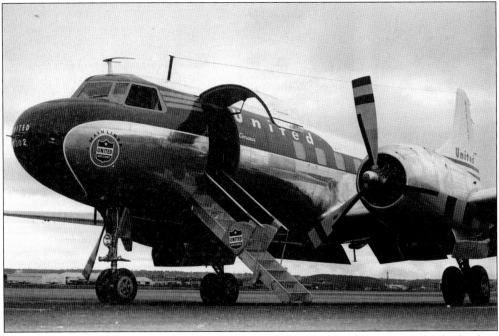

As sales for the 240 slowed, Convair looked for a way to broaden the design's appeal. The fuselage was lengthened, the wings extended, and more powerful engines installed. A total of 209 Model 340s were built for large and small airlines, and the type enjoyed an excellent safety record. United Airlines operated fifty-two 340s for 16 years without a single serious accident or fatality.

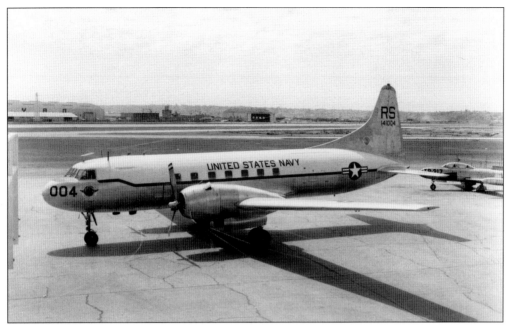

The navy bought 36 R4Y-1 transports based on the Model 340. The planes were delivered starting in 1952 and served well into the 1980s. Additionally, the navy acquired a single R4Y-1Z VIP transport and in 1957 two R4Y-2s based on the Model 440. Seen here in service with VR-5 is an R4Y-1.

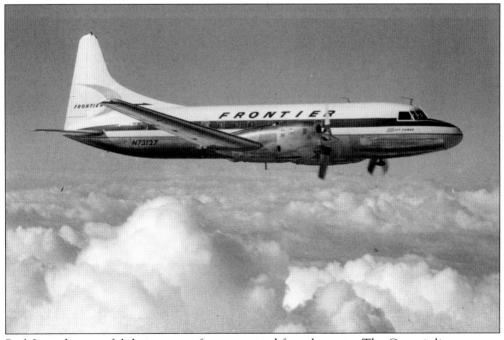

Prolific and successful designs are often converted for other uses. The Convair-liner was no exception. A large number were used as cargo carriers. Many were converted to turboprop engines for improved performance and ease of maintenance. A Frontier Airlines Model 580 is seen above.

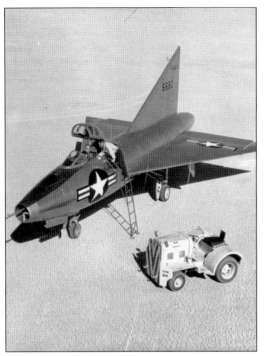

One of many milestone aircraft designed by Convair was the XF-92A. Originally conceived as a supersonic fighter in answer to an Army Air Force proposal issued in late 1945, the aircraft was designed at the Vultee Field facility in Downey, California, by Adolph Burstein, Frank Davis, Jack Irvine, and Ralph Schick. Their delta-wing design and innovative "elevons" (a combination of elevator and aileron) combined to provide the basis for future designs like the F-102, F-106, B-58, and, ultimately, the space shuttle.

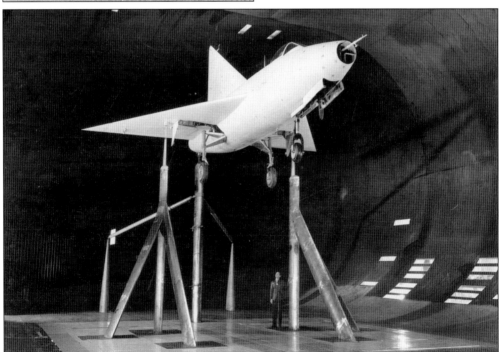

In 1947, the project was moved to San Diego, and the prototype was completed there. It was originally planned that the plane be powered by a ramjet engine, but this idea was shelved in favor of an Allison J33 turbojet. After the airframe was completed, it was shipped without an engine to Moffett Field in Sunnyvale to be tested in the Ames wind tunnel. It was then returned to San Diego, finished, and test flown at Muroc AFB on September 18, 1948.

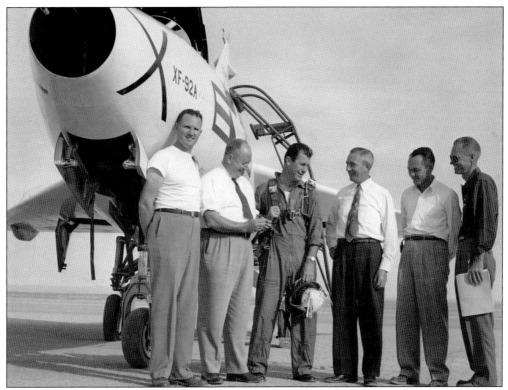

The development of the aircraft as a fighter was discontinued in 1947, but research with the plane continued, first with the air force and later with the National Advisory Committee for Aeronautics (NACA) until the plane was finally retired in October 1953. Today it is part of the U.S. Air Force Museum's collection. Seen here in front of the XF-92 are, from left to right, Clyde Bailey, Al Higgins, Col. Chuck Yeager, unidentified, Jim Love, and Joe Vensel. Yeager was one of a large number of well-known test pilots to have flown the radical delta-winged prototype.

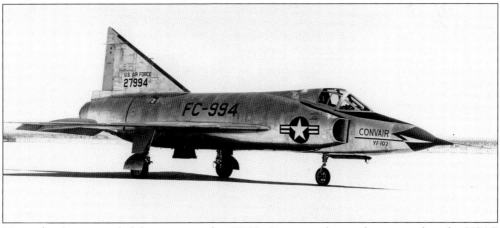

Using the data compiled from testing the XF-92, Convair submitted a proposal to the USAF for the F-102 Delta Dagger. Designed around a sophisticated fire-control system and intended to provide the continental United States with a supersonic defensive fighter to protect against possible long-range bomber attacks and with an all-missile armament, the plane first flew on October 24, 1953.

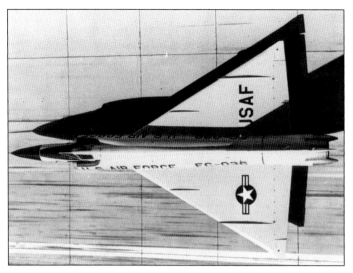

Wind tunnel data indicated that the F-102 would be incapable of supersonic flight if some drastic redesign did not occur. Convair designers decided to incorporate an area rule fuselage shape to reduce drag. This "Coke bottle" shape allowed the plane to go well past Mach 1. The new shape is clearly visible in this overhead view. Later production aircraft also had taller tails and modified wings.

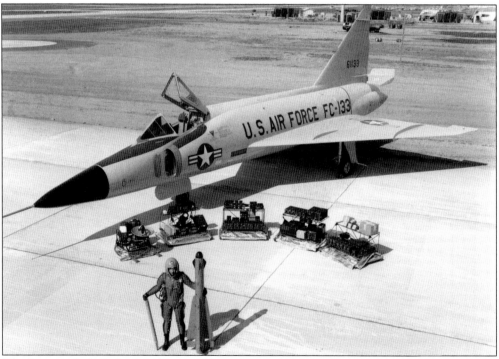

The Convair F-102 Delta Dart borrowed heavily on wartime German research in the use of delta wings for high-speed flight. Designed around the Hughes Aircraft Company's MA-1 fire-control system and Falcon missile, the prototype first flew in October 1953. Seen here at the General Dynamics test and modification site at Lancaster, California, is one of the revolutionary planes with a pilot in full gear, a Falcon, and associated equipment.

Tours in the interest of good public affairs and positive press coverage were commonplace for most large companies in the 1960s. Seen here is 1957 Miss San Diego, Kathy De Kirby, and the members of the La Jolla Town Council in front of a new Convair F-102.

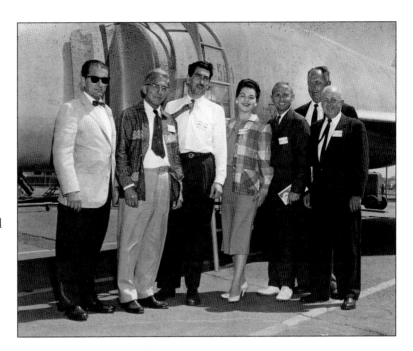

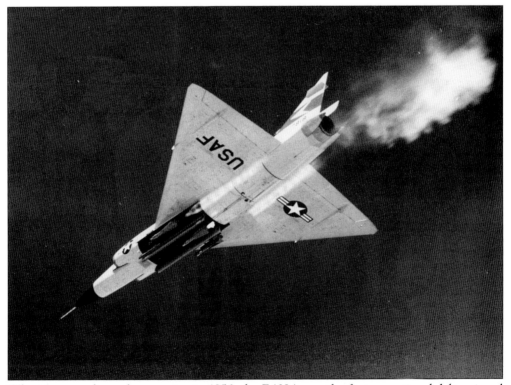

When it entered squadron service in 1956, the F-102A was the first operational delta-winged aircraft in the world, the first delta capable of exceeding Mach 1, and the first USAF fighter to be built without guns. Nine hundred seventy-five production aircraft were built, and they were named the Delta Dagger in 1957. The planes remained in frontline service until 1976.

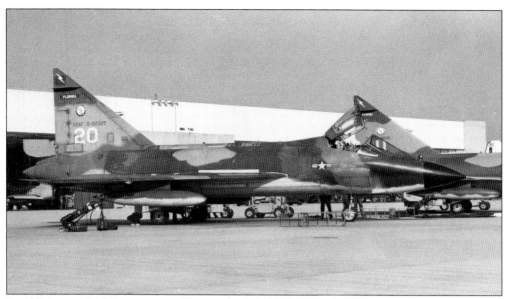

In addition to the fighter version, Convair built 111 TF-102A trainers for the USAF. Fitted with side-by-side seating, the type was subsonic in level flight because of increased drag. Most F-102 squadrons had a couple of these aircraft assigned as proficiency trainers. This aircraft was assigned to the Florida Air National Guard.

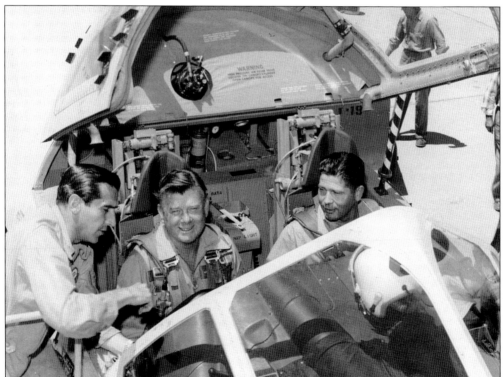

Arthur Godfrey was one of a number of high-profile celebrities who were given rides in the TF-102A. An ardent supporter of the navy and air force as well as aviation in general, at one time during the 1950s, Godfrey had flown in every active aircraft in the military inventory at one time or another.

Helen Landon of Huntingdon, Tennessee, 1957's Maid of Cotton, was given a personal tour of the F-102 acceptance line by Captain Ketching, an air force representative to Convair in March 1957.

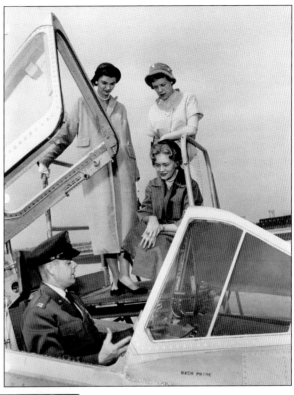

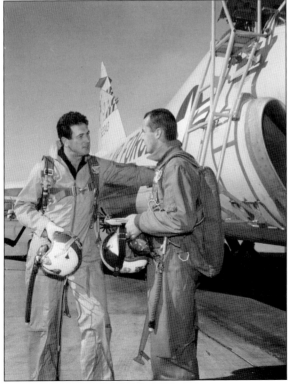

Another celebrity to get a ride in an F-102 was Rock Hudson. This possibly took place in conjunction with the 1963 film *A Gathering of Eagles*, in which Hudson played a cold war B-52 commander. Other film stars to fly in the Delta Dagger included James Arness.

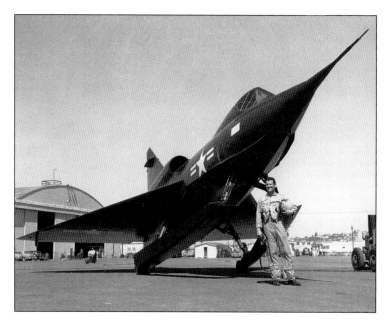

Certainly one of the most intriguing designs to come out of Convair and fly was the F2Y Seadart. The same hydrodynamic research team responsible for the hull design used on the P5Y Tradewind developed the hull shape and the overall concept for a retractable ski landing system. Under the guidance of Ernest G. Stout, a wide variety of hull and wing plans were tested before the design was finalized.

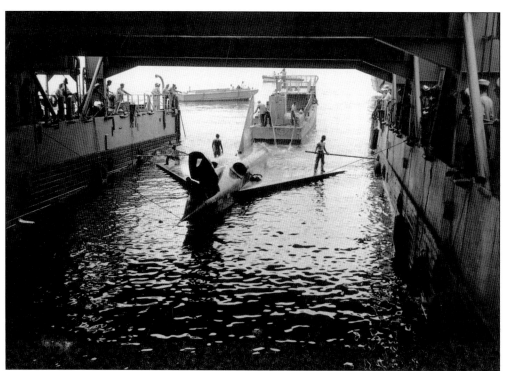

First test flown in April 1953 from San Diego Bay, the original XF2Y-1 was not capable of Mach 1 flight. The subsequent five aircraft were completed to improved YF2Y-1 standards. Planned to be armed with four cannons and unguided missiles, the aircraft was conceived as a point defense interceptor operating from landing ships, as seen here, or sheltered bays and lakes.

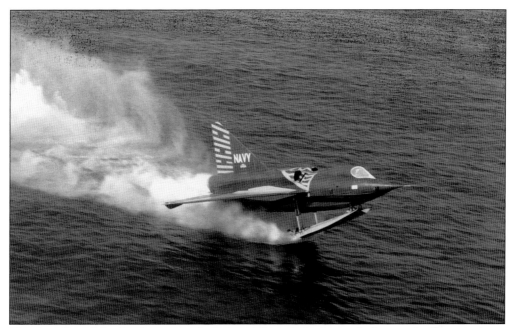

The skis allowed the Seadart to touch down at relatively high speeds then gradually settle down into the water. It was tested in single- and double-ski configurations. On August 3, 1954, Convair test pilot Charles E. Richbourg broke the sound barrier in a shallow dive. To this day, the Seadart is the only seaplane to have exceeded Mach 1.

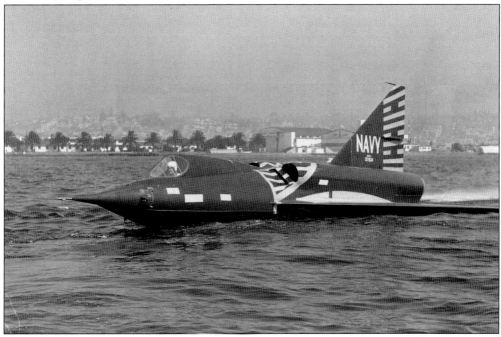

Seadart 135762 came apart in flight over San Diego Bay on November 4, 1954, killing Richbourg. The F2Y-1, seen here taxiing on San Diego Bay, failed to find a mission with the navy, and no further production took place. Nevertheless, research testing continued until 1956. Four Seadarts survive today, including YF2Y-1 135763 on a pole in front of the San Diego Air and Space Museum.

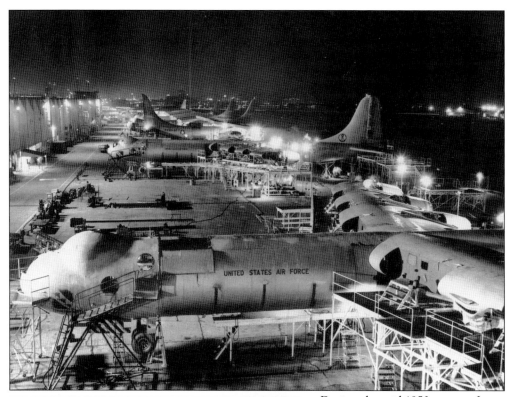

During the mid-1950s, most of the B-36 bombers in service cycled through San Diego for various upgrades and sophisticated maintenance. The B-36 was so important to the national defense system that this was a very high-priority program, and shifts ran around the clock to keep the giant bombers moving.

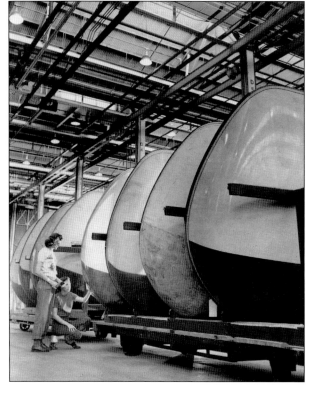

By the mid-1950s, women had once again become part of the regular workforce at most defense plants. This image shows Alice Lyons and Pat Wasley with plastic radomes destined to be installed on B-36 bombers in 1956.

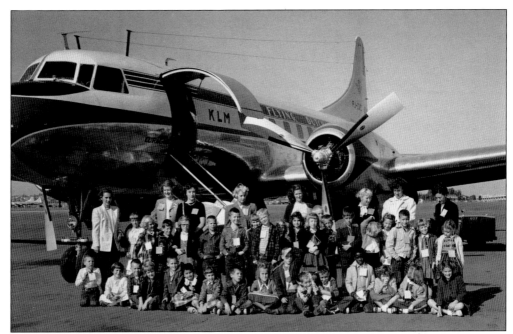

Some tours may have seemed a little more commonplace but were just as important to developing good community relations. This photograph shows Loeta Redewell and her 1957 class from the La Jolla Elementary School in front of a newly finished Convair 340 destined for KLM Airlines in Holland.

Convair offered some job placement and training opportunities to local students. The two bright ladies on the left and right of this image received the highest honors in secretarial courses at Point Loma High School and spent some time with Convair vice president and general manager B. F. "Sandy" Coggan's secretary, Catherine Chase. From left to right are Margaret Jaesler, Chase, and Marlene Peck.

Ivy Barker Priest is seen here signing a dollar bill for a Convair employee during a tour of the factory on April 4, 1955. Priest served as U.S. treasurer from 1953 to 1961. She was later elected as a Republican to the office of California state treasurer, serving two terms from 1967 to 1975. She is the mother of Pat Priest, an actress most famous for playing Marilyn Munster in the 1960s television show *The Munsters*.

While not interested in buying the F-102, the RAF was very interested in its flight characteristics. Members of the British Royal Air Force Flight Evaluation Team spent two weeks at Edwards Air Force Base evaluating the Convair F-102A delta-winged interceptor. The pilots were, from left to right, Flight Lt. I. B. Webster, Wing Comdr. J. L. W. Ellacombe, Wing Comdr. H. Bird-Wilson, Flight Lt. E. C. Rigg, and Wing Comdr. F. R. Bird.

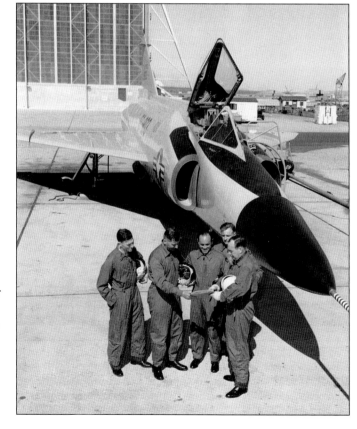

James "Skeets" Coleman pilots the revolutionary XFY-1 Pogo on a test flight out of NAAF Brown Field in 1954. Using some captured German research information and the newly designed Alison YT40 turboprop engine, the design was intended to provide the navy with a vertical takeoff and landing escort fighter capable of operating from the decks of cargo vessels. In practice, the plane was very difficult to land, and the complex power plant and transmission suffered teething problems.

In addition to the Pogo's awkward configuration, the airplane had a complex gearbox driving contra-rotating props, a largely untested power plant, and awkward controls. The plane was to be armed with four 20-millimeter cannon or 48 unguided rockets in its wingtip pods. Three Pogos were built, but only the first flew. Today it is part of the National Air and Space Museum collection.

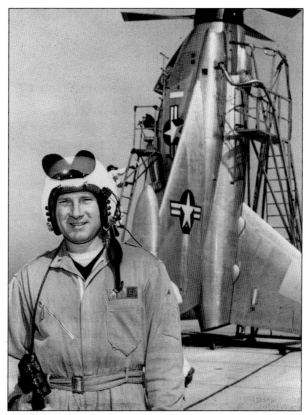

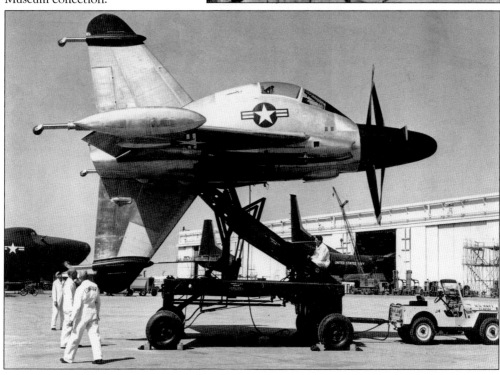

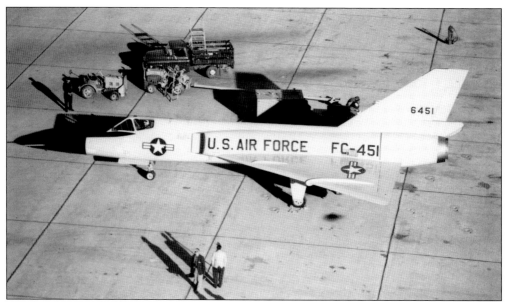

Originally designated the F-102B, the airplane that would replace the Delta Dagger was very nearly cancelled before production even started. Initial flight tests were disappointing, but Convair persisted in making changes and the air force eventually ordered 260 of the F-106A as well as 63 two-seat F-106B trainers.

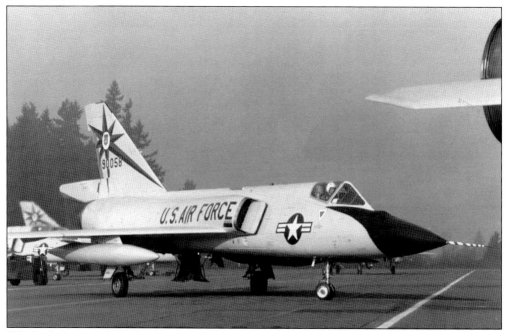

While the wing of the F-106 was similar to that of the F-102, the fuselage was completely redesigned. Incorporating an area rule shape from the outset with larger engine intakes and a very powerful afterburning turbojet, the F-106 was capable of speeds in excess of Mach 2.0. The airplane was delivered to 15 fighter interceptor squadrons beginning in May 1959. The aircraft in this photograph served with 318 Fighter Interception Squadron (FIS) at McChord AFB near Seattle, Washington.

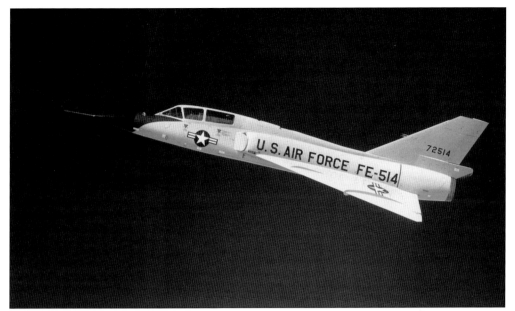

The tandem two-seat F-106B trainer was actually slightly faster than the single-seat fighter as a result of its fuselage shape. Fully combat capable, the two-seaters were assigned to most squadrons as proficiency trainers and also saw duty as flying test beds and chase planes. Guided missile armament was carried in a weapons bay in the lower fuselage. Both of the F-106 variants were known as the Delta Dart.

The F-106 continued in frontline service until the McDonnell Douglas F-15 started to replace it in 1972. The Delta Darts were then passed on to six Air National Guard squadrons and continued in service until August 1988. This aircraft was assigned to the California Air National Guard at Fresno.

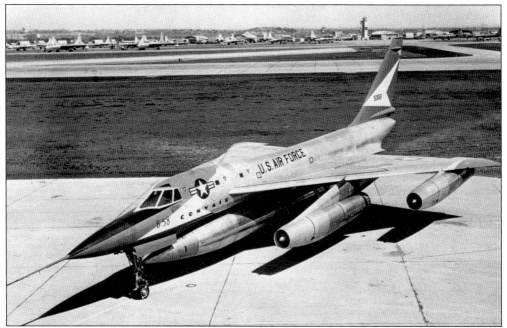

In October 1952, Convair won a competition to produce a new long-range supersonic bomber for the air force. The result of nearly six years of detailed studies and development, the new bomber would be designated the B-58. Using the delta form pioneered by the XF-92A, the plane had an area rule fuselage and four GE J-79 turbojet engines with afterburners.

Named the Hustler in 1956, the 86 Fort Worth–built production aircraft started delivering in 1960. The plane held no less than 19 official speed records. An airplane this sophisticated was difficult and expensive to operate, and it suffered a series of accidents in its early career. This and a number of operational issues led the plane having a relatively short service life, being retired by the end of 1969.

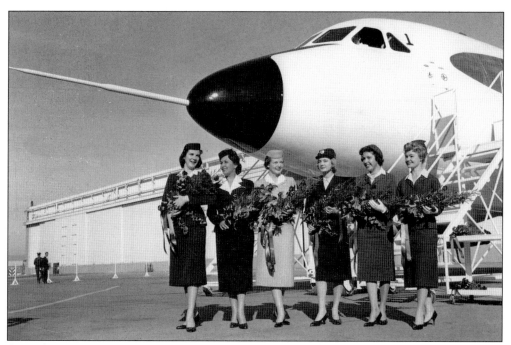

One of Convair's most significant financial disasters came about as the result of a joint effort with Howard Hughes to develop a long-range jet transport for TWA. The timing of the Model 22 (880) development coincided with that of the Boeing 707 and Douglas DC-8. This and other issues reduced the potential market for the type. Production went ahead, and 65 were eventually built. To celebrate the official rollout, 880 flight attendants from the six airlines to have signed contracts for the plane were hosted at the factory. Shown here are ladies representing TWA, Swissair, Scandanavian Airline System, Capital, REAL, and Transcontinental SA. Unfortunately for Convair, all but TWA would eventually cancel their orders.

Seen here at NAS North Island after the first flight of the Model 880 are, from left to right, R. M. Bloom, Don Germeraad, B. B. Gray, S. Coggan, E. Davies, J. Moroney, and Phil Prophet. Germeraad and Prophet were the test pilots for the program. FAA safety precautions dictated that the first flight terminate at the naval air station rather than Lindbergh Field.

Before the 880s first flight, Convair decided to design a larger version to compete with Boeing's Model 720. Convair's designers lengthened the plane, gave it new, more powerful, fuel-efficient turbofan engines. The new design, called Model 30, was ordered by American Airlines, Swissair, and REAL of Brazil. However, intense competition from Boeing, limited seating, and continued interference by Howard Hughes led to small orders and only 37 were built, mostly for Swissair.

Five

TO THE MOON AND BEYOND

In 1954, General Dynamics purchased a majority interest in Convair. The General Dynamics Convair Division became best known for its production of the Atlas, the first successful intercontinental ballistic missile (ICBM) able to fly up to 5,000 miles and carry a nuclear warhead. During the late 1950s, the cold war heated up when the Soviet Union shocked the world with the successful launch of SPUTNIK. The United States had underestimated Soviet technology. The rush to catch up created the "space race." The space program became top priority for the United States as well as for Convair. This intense focus left Convair with little time for building aircraft. The last full aircraft built by the company was the Model 48 Charger. Instead, the company would continue on as an aircraft subcontractor, building components for other aircraft companies until 1994, when the Aircraft Structure Unit was sold to McDonnell Douglas.

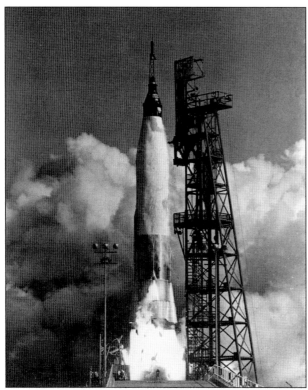

The birth of the Atlas began with the MX-774. In 1947, the U.S. Air Force contracted with Convair to design and build a ballistic missile. Seen here is a static test stand built on Point Loma (San Diego) during the early years of the project. The first hot engine run was made there on the number one MX-774 missile in November 1947. Three missiles were launched in 1948 at White Sands Proving Grounds in New Mexico. Due to lack of funding, the project was put on hold. Convair continued limited studies until 1951. With the outbreak of the Korean War and increased military appropriations, attention returned to the ICBM.

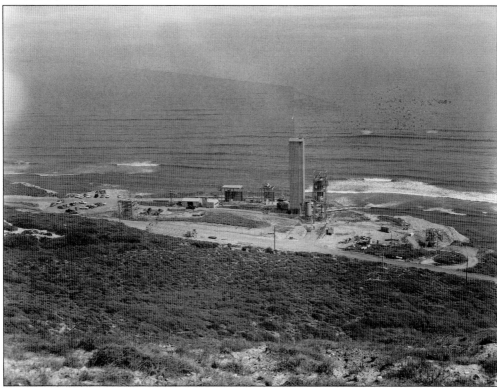

On January 1951, the Air Research and Development Command granted to Convair contract MX-1593, which later became Project Atlas. By 1957, Convair created the Convair-Astronautics Division to accommodate the production of the Atlas as well as the development of other missile projects. Picked out in this aerial view are some of the buildings added to the original facility during 1959, including 1) office building; 2) telephone equipment room; 3) tooling building; 4) additional factory space; 5) vibration and structures lab; 6) gas flow lab; and 7) training building.

During the early years, Atlas was transported by lightly guarded caravans, traveling 2,622 miles from Kearny Mesa, California, to Cape Canaveral, Florida. The trips were made during daylight hours. Seen here is Convair cinematographer Mark Irwin filming one such convoy. Notice the roadside sign warning of enemy attack.

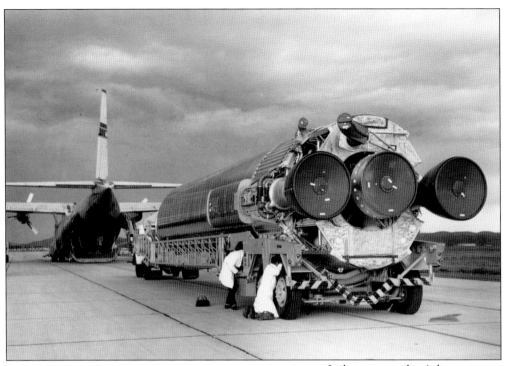

In later years, the Atlas was transported by U.S. Air Force C-133s. Atlas was transported by truck from the Kearny Mesa factory to Miramar Naval Air Station and then loaded into a C-133 and flown to Cape Canaveral, Florida, for launching.

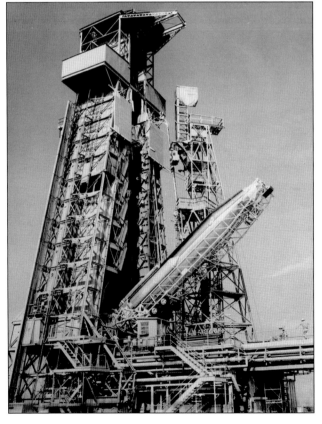

The Atlas was placed in a carriage for safe transport by truck and the same carriage was later used to raise the missile into launch position.

Because the Atlas was such a powerful lifting platform, it was used by the United States in its space program. Seen here is an Atlas/Agana SLV on the test stand at Complex 14, Cape Canaveral, Florida, launching the 10C satellite. Notice the moon in the background, a future target for several space missions.

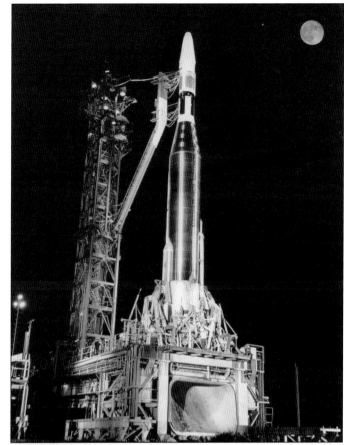

The original seven American astronauts are pictured May 8, 1961, prior to their trip to Washington, D.C., for a press conference, and three days after the Mercury/Redstone suborbital flight of Alan Shepard. From left to right are "Deke" Slayton, Gus Grissom, John Glenn, Scott Carpenter, Gordon Cooper, Wally Schirra, and Alan Shepard.

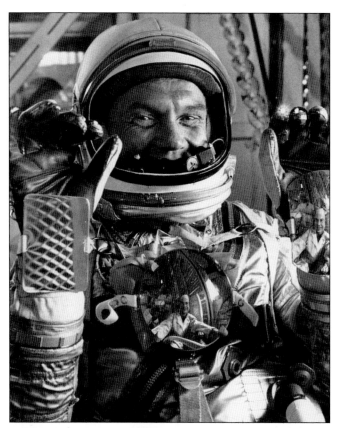

John Glenn suited up prior to being inserted into Friendship 7 on Atlas 109D. This process was repeated several times between the first attempted liftoff and February 20, 1962, when he was launched into space and successfully orbited the earth three times. It was a great day for all America and the world.

The Mercury astronauts came to San Diego on several occasions to tour the Atlas assembly line at General Dynamics/Astronautics. Seen here are John Glenn (front, right) and Scott Carpenter (front, left) walking with Convair executives.

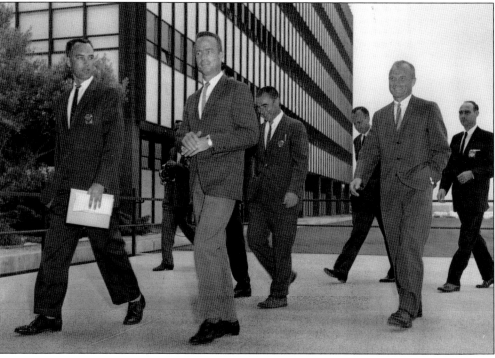

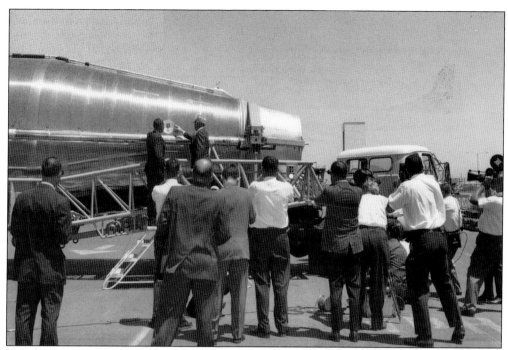

Mercury-Atlas program manager Dick Keene (right) and Space Programs–Convair program manager Charlie Ames (left) place the Mercury Project seal on an Atlas at the Kearny Mesa plant.

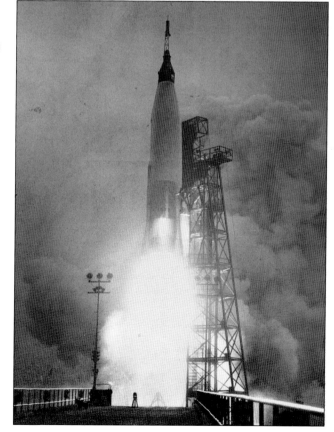

Pictured here is liftoff of the Atlas 107D with Scott Carpenter aboard Aurora 7. Scott Carpenter was the second American to orbit the earth and the fourth American in space, following Alan Shepard, Gus Grissom, and John Glenn.

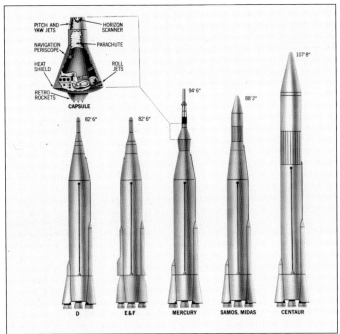

This diagram of launch vehicles was produced by Convair. Notice the Mercury capsule in the upper left-hand corner. The Mercury astronauts were confined in a small space.

Gordon Cooper visited General Dynamics/Astronautics' Kearny Mesa plant on Publicity Day for the SLV III rollout on February 4, 1963. Prior to shipping to Florida, Cooper signs an Atlas and points it in the right direction. From left to right are an unidentified colonel, Gordon Cooper (Mercury-Atlas 9 astronaut), Charles Ames (scientist—Space Launch Vehicle III Program), and Cal Fowler (Atlantic Missile Range test conductor).

Steelworkers reinforce bars in the walls of a 175-foot-deep Atlas silo enclosure. Located in Salina, Kansas, this silo had 600 tons of reinforcing steel and more than 3,000 cubic yards of concrete.

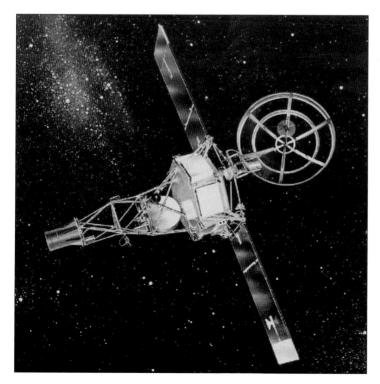

In addition to the use of the Atlas in the Mercury Program, Atlas boosters also aided in the exploration of the solar system's outer planets. On August 27, 1962, the Atlas was used to launch Mariner 2 to Venus, the first successful interplanetary spacecraft. The Mariner 2 sent the first close-up photographs of another planet. Forty-four years later, the Atlas V 551 rocket launched a spacecraft on the first mission to Pluto.

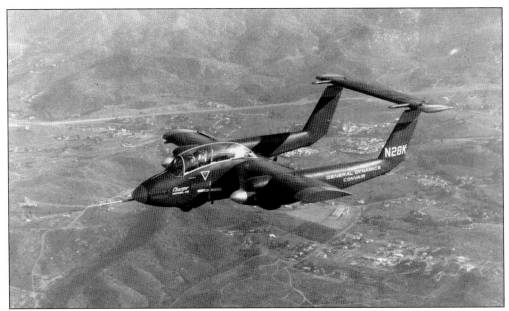

The last complete aircraft to be built by Convair was the Model 48 Charger. The navy had issued a requirement for a new counter-insurgency aircraft, and Convair was already well advanced with a design to meet it. Convair proceeded with the manufacturing of a prototype as a private venture since the navy had not yet decided which of the competing designs to award the contract.

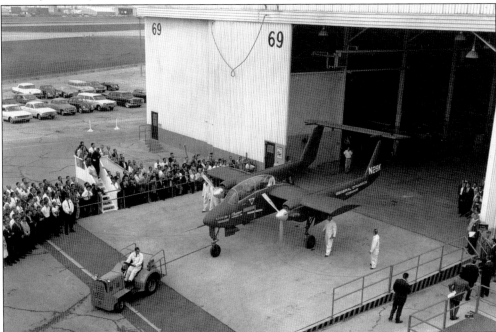

By the time the prototype rolled out of the factory on September 29, 1964, the navy had decided on the North American Aviation design. Convair's calculated risk had failed. However, the army and the marines preferred the Charger, so a flight test contract was awarded. Before a scheduled "fly off" could take place, the Model 48 was destroyed during a test flight by a navy pilot; another example was not built.

The Atlas/Centaur space launch vehicle played an important role in the American space exploration program during the 1960s and 1970s. Development began in 1958 under the direction of Dr. Krafft A. Ehricke. The Centaur launched the Lunar Surveyor spacecraft, orbiting Astronomical Observatory Copernicus (seen here) and Pioneer 10 (the first and only to visit the planet Mercury).

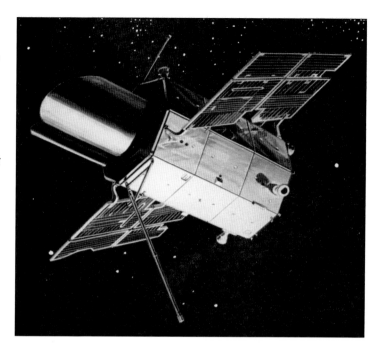

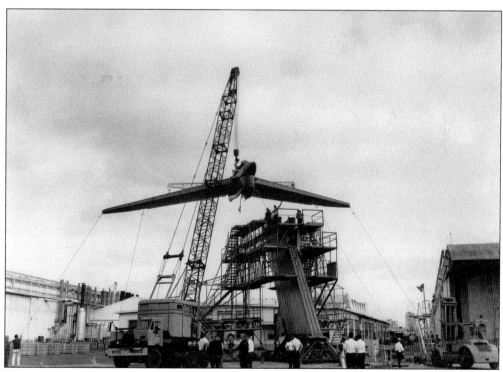

One of the last contracts to be handled by the aircraft division of Convair/General Dynamics was the construction of Lockheed C-141 tail sections. After assembly, the tails would be shipped to Lockheed's Marietta Division in Georgia for final assembly. This photograph was taken during a fit check in San Diego.

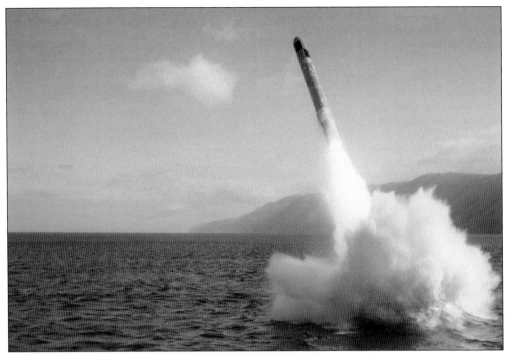

In 1972, Convair received a navy contract to develop the Tomahawk, a long-range subsonic cruise missile that could be launched from surface ships, submarines, aircraft, or the ground. The Tomahawk missile was first used during Operation Desert Storm in 1991 with great success.

The Convair Division not only produced aircraft components. They also worked on the first space shuttle orbiter mid-section fuselage, delivered to North American Rockwell, producer of the Orbiter in 1975.

The last aircraft components to be produced at the San Diego plant were fuselage sections for the McDonnell Douglas DC-10 airliner. This January 21, 1970, image shows the first completed section emerging from the plant, nearly ready for shipment to Long Beach. Originally these sections were flown north in "Super Guppy" cargo planes. Later they were shipped by rail. In 1987, Convair began producing the McDonnell Douglas MD-11 fuselage and continued producing it until late 1995. In 1994, the Aircraft Structure unit was sold to McDonnell Douglas, and in 1996, Convair division operations were discontinued, marking the end of an era. Today most neighborhoods in San Diego have a resident who worked at Convair at one time. Still, nearly a decade after the company passed from the San Diego scene, tens of thousands of San Diegans celebrate a seminal connection with Ruben H. Fleet, his company, and his popular slogan, "Nothing short of right is right."

ACROSS AMERICA, PEOPLE ARE DISCOVERING
SOMETHING WONDERFUL. *THEIR HERITAGE.*

Arcadia Publishing is the leading local history publisher in the United States. With more than 4,000 titles in print and hundreds of new titles released every year, Arcadia has extensive specialized experience chronicling the history of communities and celebrating America's hidden stories, bringing to life the people, places, and events from the past. To discover the history of other communities across the nation, please visit:

www.arcadiapublishing.com

Customized search tools allow you to find regional history books about the town where you grew up, the cities where your friends and family live, the town where your parents met, or even that retirement spot you've been dreaming about.